IMAGES
of America

PINETOP-LAKESIDE

The people are going to miss the frontier more than words can express.
For four centuries they heard its call, listened to its promises,
and bet their lives and fortunes on its outcome.

—Walter Prescott Webb

IMAGES
of America

PINETOP-LAKESIDE

All the Best -

Joan Baeza

Joan Baeza

ARCADIA
PUBLISHING

Copyright © 2014 by Joan Baeza
ISBN 978-1-4671-3216-9

Published by Arcadia Publishing
Charleston, South Carolina

Printed in the United States of America

Library of Congress Control Number: 2014932394

For all general information, please contact Arcadia Publishing:
Telephone 843-853-2070
Fax 843-853-0044
E-mail sales@arcadiapublishing.com
For customer service and orders:
Toll-Free 1-888-313-2665

Visit us on the Internet at www.arcadiapublishing.com

Lovingly dedicated to Paula and Bill.

CONTENTS

ACKNOWLEDGMENTS

I could not possibly have written this book without the help of at least 100 other people. I do not have space to thank each person individually, but I hope those I left out know how grateful I am for their willingness to share their pictures and stories.

Special thanks are in order for research assistant Jim Snitzer, who volunteered to scan all the images. I owe him a dinner at Charlie Clark's. Many thanks to Marion Hansen, who shared pictures, journals, and diaries he has collected of Lakeside pioneer families.

Some contributors were the direct descendants of early Pinetop-Lakeside pioneers, including Ferrell Fish, Raymond Johnson, Sue and Sonny Penrod, Jack Reed, Bobbie Stephens Hunt, Anthony Cooley, Lonnie Amos West, Pam Fish-Tyler, the Webb family, Arlene Mcabe, Louise Willis, Loretta Lee Jennings, Nancy Stone, Renee Penrod, Anna Jackson, Hazel West Fish Gillespie, Arlene Fish McCabe, Leo Petersen and Wanda Petersen Tenney, Louise Johnson McCleve, Norma Larson, Melba and Anna Gardner, Anne Snoddy-Suguitan, Maryann Scorse Coulter, and Craig Hansen.

Thanks to Jack Wood of White Mountain Computers, who kept my computer cruising and contributed images.

Professional photographers who graciously gave me permission to use their photographs were David Widmaier, Vennie White, Lloyd Pentecost, and Judi Bassett. Steve Taylor and Bill Lundquist contributed original artwork. Author Gene Luptak shared photographs and information from his book *Top o' the Pines*. Author Robert Moore sent us digital images from *The Civilian Conservation Corps in Arizona's Rim Country*. Greg Tock, editor and publisher of the *White Mountain Independent*, not only let us use his copyrighted images, he also tracked them down! Some of the contributors with second- and third-generation connections to Pinetop-Lakeside are Gary Butler, Gary Renfro, Gloria Guenther, Diana Butler, Georgia Dysterheft, Jo Ann Hatch, Maxine Ann Turnbull, and Julie Wilbur West.

First-generation Pinetop-Lakeside contributors include Bev Garcia, Bonnie Lane, Bill and Tricia Gibson, Mary Ellen and Chuck Bittorf, Ginny and Jerry Handorf, Brenda Mead Crawford, Julie Aylor, Johnnie Fay McQuillan, Mark Sterling, Dwayne Walker, Kevin Rowell, Betty Jarrett, Lynda Marble, Phil Hayes, and Geoff Williams.

Federal, state, and local agencies have been of great help, especially the USDA-Forest Service, the Arizona Game and Fish Department, the Pinetop Fire Department, the Lakeside Fire Department, and the Pinetop-Lakeside Police Department. The White Mountain Sheriff's Posse provided many good images.

Public institutions are always major contributors to a book like this, and I thank the Navajo County Library District, the Pinetop-Lakeside Library, the Snowflake Heritage Foundation, the Pinetop-Lakeside Historical Society Museum, the Victorian, and the Show Low Historical Society Museum.

My thanks go out posthumously to historians Leora Petersen Schuck and Ben Hansen for their many wonderful stories of the Lakeside pioneers.

Most of all, I thank God for creating this beautiful place.

INTRODUCTION

For longer than anyone can remember, people who love the outdoors have called Arizona's White Mountains "God's Country." In modern times, they come in waves to fish, hunt, camp, hike, and backpack, ride ATVs, snowmobiles, and horses, scale mountains and canyons, golf, ski, cut Christmas trees, bird-watch, observe wildlife, and take pictures. They come to restore their souls in the pine-laden air.

The town of Pinetop-Lakeside is a gateway to this mountain paradise. Approximately 4,200 people call the incorporated area home, but cabins and country clubs are scattered throughout the surrounding forests and woodlands. For a small town, the population is surprisingly cosmopolitan. People congregate at barbecues, chili cook-offs, festivals, art shows, concerts, and sports events. They come to eat, drink, and converse at one of many good restaurants. Scarcely a week passes without a public benefit of some kind. Mountain people help each other.

Those who live here call it simply "the mountain." They live and work and grow old by the seasons. They live on the mountain because they want to. It is not unusual to find a fifth-generation descendant of a pioneer family living here. They go away, but they come back.

Pinetop-Lakeside is the headquarters for the Lakeside Ranger District of the two-million-acre Apache-Sitgreaves National Forests, whose lands range in elevation from around 6,000 feet in the piñon-juniper woodlands, to forests of pine, spruce, and fir on the 11,400-foot-high Mount Baldy. The "A-Bar-S," as it is known locally, nurtures 24 lakes and reservoirs and more than 700 miles of trout streams.

The southern boundary of Pinetop-Lakeside borders the Fort Apache Indian Reservation, the traditional homeland of the White Mountain Apache Tribe. The 1.6-million-acre reservation was once much larger, including land now belonging to the town. The past, present, and future of reservation and off-reservation communities are intertwined. Tourists fish and camp on tribal lakes and streams, hunt trophy elk, ski at Sunrise Resort, dine at Hon-dah Casino and Convention Center, and work, teach, and drive on tribal lands. Tribal members shop, eat out, work, go to movies, attend school, and often live in Pinetop-Lakeside. Tribal and non-tribal law enforcement, as well as fire and emergency services, work together under cooperative agreements.

Humans have left their footprints in these mountains for as long as 14,000 years. Ancient hunters passed this way. Except for stone artifacts and signs of campsites, the hunters left no trace. The first distinct culture archaeologists recognize in the White Mountains is known as "Mogollon." These ancestors of Hopi and Zuni people cultivated corn, beans, squash, and sunflowers, domesticated wild turkeys, and made pottery. They traded with people as far away as Central America and California. By 1450 A.D., they had moved on. Archaeological evidence suggests that Athabaskan-speaking people began to drift into the Southwest in small bands from the north around the same period that the Ancestral Pueblo people left.

The first known presence of Europeans in the White Mountains was Francisco Vazquez de Coronado's expedition, which left New Spain in 1540 in search of the fabled Seven Cities of Cibola. Stewart Udall, in his book *In Coronado's Footsteps*, claims Coronado crossed the Gila River, then climbed a tortuous ascent north into the White Mountains through or near the

7

present communities of Whiteriver, Pinetop-Lakeside, and McNary on his way to Zuni Pueblo. The Spanish conquest and colonization of the Americas brought gifts to indigenous people, as well as suffering. Once Navajo and Apache people adopted a horse culture, they impeded the settlement of northern Arizona for 250 years.

Five major historical events affected the colonization and environment of the Pinetop-Lakeside area: the introduction of horses, cattle, and sheep by Hispanic and Anglo ranchers; the establishment of Fort Apache by the US military; the completion of the Atlantic & Pacific Railroad across northern Arizona; the creation of the US Forest Service and the beginnings of a timber industry; and the gradual shift to an economy based on outdoor recreational tourism.

Sheepherders from Spanish colonial New Mexico were driving bands of livestock into northern Arizona by the 1850s, but they did not colonize the mountain country until much later. They practiced transhumance, driving their flocks to summer camps in the mountains and then back to lower country in winter. Cattlemen began to drift into the White Mountains after the Civil War. They were a venturesome breed and a law unto themselves. Men came on ahead, scouting out locations and building crude cabins before they sent for their families.

Mountain families were poor in worldly goods until Fort Apache was established in 1871. The remote Army outpost provided protection for both white settlers and Apaches, as well as a ready market for hay, grain, beef, and fresh produce. The new post created work for freighters, skilled craftsmen, and laborers. More than any other factor, the presence of Fort Apache opened up the White Mountains for settlement.

In 1873, the White Mountains were surveyed, mapped, and explored by the US Corps of Topographical Engineers. Cartographer Lt. George M. Wheeler stood on the top of Mount Baldy on a summer day and wrote, "Few worldwide travelers in a lifetime could be treated to a more perfect landscape, a true virgin solitude, undefiled by the presence of man."

Corydon Eliphalet Cooley came to Arizona as a prospector in 1869, then stayed as an Army scout and rancher. Married to two of Chief Pedro's daughters, he was largely responsible for maintaining peaceful relations between Apaches and white settlers in the White Mountains. Other pioneer ranchers in the Pinetop-Lakeside area included Will Amos, William Morgan, the Scott brothers, and Jim Porter. They ran sheep and cattle on public-domain lands and on the Apache reservation.

Brigham Young sent wagon trains of Latter-day Saints down the trail from Utah to colonize the Little Colorado River Valley in the late 1870s. They bought out many of the earlier settlers and organized true communities with schools, churches, and cooperative mercantile stores, built dams and irrigation systems, and raised crops and cattle. In spite of enduring extreme hardships and years of cruel persecution, they prevailed, and they maintain a strong influence in today's culture.

In 1881, the Atlantic & Pacific Railroad came rumbling into Holbrook, 60 miles north of Pinetop-Lakeside. Many of the early mountain people made a living supplying railroad crews with beef and elk meat, or by cutting trees for railroad ties. More significantly, a lucrative freighting business between Holbrook and Fort Apache was established to supply feed and supplies to the army.

When the heyday of large corporate cattle ranches in northern Arizona came to an abrupt halt near the turn of the 20th century, new economic opportunities arose in the mountains. Arizona's Mogollon Rim is a steep, 200-mile-long escarpment that juts up from the desert floor to the mile-high Colorado Plateau and runs diagonally across the state from northwest to southeast. Arizona's high country nurtures the largest continuous stand of ponderosa pine in the world. Small sawmills provided a living for many mountain families in the early days of settlement. The next century saw the rise of a timber industry.

Statehood for Arizona had not yet come to pass in 1905 when the US Forest Service was established. World War I raised the demand for lumber, and the national forests were called on to help meet that demand. The federal government offered timber sale contracts to stimulate commercial logging. Entrepreneurial banker Tom Pollack of Flagstaff saw a fortune in trees. Pollack and his partners built the Apache Railway from Holbrook to their new sawmill near Cluff

Cienega, in the midst of the vast pine belt of east-central Arizona. The town they called Cooley was later renamed McNary after James G. McNary, one of the partners in the Cady Lumber Co. of Louisiana. The company reorganized several times, and was known as Southwest Forest Industries until it shut down.

The US Army left Fort Apache in 1922, with the remaining cavalry troopers and Apache Scouts moving to Fort Huachuca in southern Arizona. A Bureau of Indian Affairs boarding school was constructed at the old fort. It continues to operate as Theodore Roosevelt School today. The former cavalry outpost is now Fort Apache Historic Park, the home of the White Mountain Apache Cultural Center and Museum, which preserves the culture and language of the White Mountain Apache people.

In the 1950s and 1960s, the White Mountain Apache Tribe created a recreation enterprise, building lakes, campsites, stores, and roads in its goal of becoming a major economic force in the region. At the same time, Pinetop-Lakeside developers began selling lots for summer homes, country clubs, and RV parks. The tribe, the USDA-Forest Service, the Arizona Game and Fish Department, and the Town of Pinetop-Lakeside have worked together for the past half century to manage natural resources and promote economic development. Cattle ranching and forest products industries still flourish in the White Mountains, but tourism is the major source of revenue for Pinetop-Lakeside. It is primarily a resort and retirement center. In addition to a 200-mile-long system of interconnected, multiuse forest trails, residents have easy access to a regional medical center, a regional airport, a community college, museums, libraries, art galleries, and large retail stores.

To visit Pinetop-Lakeside is a weekend adventure. To live on the mountain requires a certain mindset. Those who value quality of life over income, nature over design, and stars over bright lights live with pride in their lifestyle and history. The community runs on volunteerism. The spirit of community still underlies all of life in "God's Country."

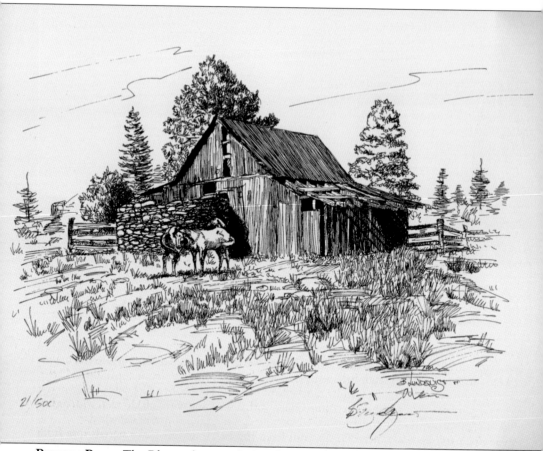

RHOTON BARN. The Rhoton barn, in Lakeside, was an iconic landmark for decades, painted and sketched by artists and photographed by nearly every tourist passing through. It was part of the Rhoton Dairy, which was owned and operated by Charles Lowe Rhoton, his wife, Louise, and their two sons, Dow and Royal, in the 1920s. Bill Lundquist, an Arizona artist who was the vice president and manager of the First National Bank in Pinetop from 1985 to 1992, made this sketch. (Courtesy Bill Lundquist.)

One

FORT APACHE, CROOK, AND COOLEY

The US military knew next to nothing about White Mountain Apaches or their isolated mountain homeland in 1869. Army officials believed, mistakenly, that White Mountain Apaches had been aiding the Chiricahuas in raids on white ranchers. In July of that year, Bvt. Col. John Green of the US 1st Cavalry was sent north from Camp Grant with a scouting party of 120 men with orders to kill or capture any hostile Indians they encountered, and to destroy their cornfields.

As Green's troopers advanced up the trail from the Black River, smoke signals rose from ridge tops announcing their progress. Shortly after Green arrived at the White River, he had an unexpected visit from Miguel, leader of the Carrizo band, who invited him to visit his *rancheria*, or village. Green sent Capt. John Barry and a detail back to Carrizo with Miguel with orders to kill anyone who resisted.

To Barry's astonishment, men, women, and children in Miguel's camp ran out to greet the soldiers, carrying corn for their horses and inviting them to a feast. Barry's report stated that he "would have been guilty of cold-blooded murder had he fired upon those people."

Three American prospectors had been staying in Miguel's camp. One was Corydon E. Cooley, a former Union soldier, who assured Green that the White Mountain Apaches were peaceful. After conferring with Apache leaders, Green urged the government to establish a military post and reservation on the White River. He argued that it could serve as a forward operating base against hostile bands. Not all Apaches wanted a military presence in their land, but others saw an Army post as an opportunity to earn cash and receive regular rations.

Green chose a bluff at the confluence of the east and north forks of the White River for a camp. He wrote, "I have selected a site for a military post on the White Mountain River which is the finest I ever saw . . . It seems as though this one corner of Arizona were almost its garden spot, the beauty of its scenery, the fertility of its soil and facilities for irrigation are not surpassed by any place that ever came under my observation."

In May 1870, troops were moved north from Camp Goodwin to begin construction of what was first called Camp Ord. It was not officially designated Fort Apache until 1879. The post was built on 12 square miles of military preserve surrounded by the Fort Apache Indian Reservation.

Gen. George C. Crook, commander of the Department of Arizona, arrived at the post on August 12, 1871. Shortly afterward, he decided to construct a new military road that would

connect Camp Apache with Camp Verde and Fort Whipple, his headquarters. As Crook rode off on his Army mule to inspect the route, he ordered Capt. Guy Henry to enlist the first company of 50 White Mountain Apache Scouts. Crook, experienced in Indian warfare, believed it would take Apaches to find other Apaches. The scouts proved to be invaluable in Crook's 1872–1873 campaigns against Apache groups who continued to raid white settlements. Alchesay, already a respected leader at age 19, was the first of four White Mountain Apache Scouts to receive the Medal of Honor for valor. Others were Machol, Blanquet, and Chiquito. All told, 11 Indian scouts received the nation's highest military honor during Crook's winter campaigns.

Corydon E. Cooley served Crook chiefly as a guide and interpreter with the scouts. Cooley was married to two of Chief Pedro's daughters, Mollie and Cora. Mollie was a cousin of the influential Chief Alchesay.

By 1874, Cooley was ready to settle down to family life. He and a partner, Marion Clark, homesteaded a ranch on Show Low Creek, north of Fort Apache, although Cooley continued to live near Fort Apache and serve the Army. At some point, Cooley and Clark decided to split the partnership and play a game of Seven Up for the ranch. Local legend alleges that they played cards all night until Clark finally told Cooley, "Show low and take the ranch." Cooley cut the cards and showed the deuce of clubs, winning the ranch and cattle. From then on, the community was known as Show Low.

Cooley's wife, Cora, died in 1876 following the birth of their daughter Lillie. Cooley formed a partnership with Henry Huning, a New Mexico rancher, and built a large home in Show Low. They raised purebred Hereford cattle, farmed, and ran a shingle mill. Cooley sold his interest in the Show Low ranch to Huning in 1888. He and Mollie moved to land on the Fort Apache Reservation, south of Pinetop, on which Mollie had grazing rights. The Cooleys built a large ranch home that became an overnight stop for military personnel, travelers, and freighters.

Mollie was well known for her cooking, hospitality, and good-natured disposition. Brig. Gen. Thomas Cruse, in *Apache Days and After*, wrote, "On all my visits their table had groaned under meals of beef, game of all sorts, and civilized incidentals."

Crook's aide, Capt. John G. Bourke, wrote, "Cooley's efforts were always in the direction of bringing about a better understanding between the two races." Cooley died at his ranch on March 19, 1917. He was buried with full military honors in the Fort Apache Cemetery. He left a legacy of goodwill and an army of descendants.

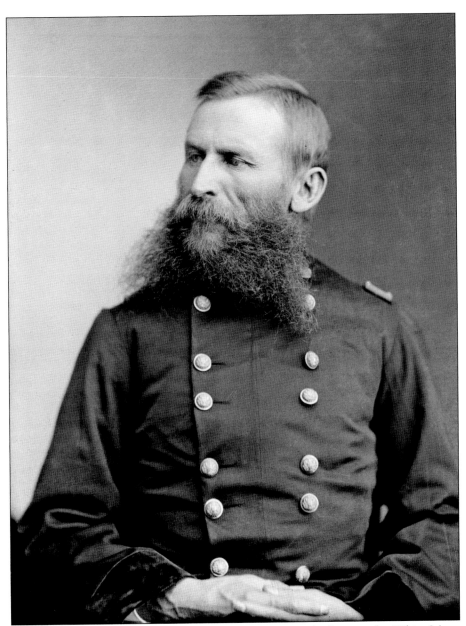

GEN. GEORGE C. CROOK. White ranchers and farmers were looking at the White Mountain Apache homeland as an ideal place to locate, but the defending Apaches held them at bay. Tales of lost gold mines were attracting prospectors as well. Settlers and prospectors wanted the government to solve the "Apache problem." Government policy was for all Apache bands to be confined in one place, San Carlos. For this purpose, the Army appointed Gen. George C. Crook commander of the Department of Arizona in 1871. Crook believed that the only way the Army could fight Apaches successfully was with other Apaches. He ordered the formation of the first group of Apache Scouts. They were the "special forces" of the time. Carrying supplies on pack mules instead of cumbersome wagons allowed his forces to move swiftly over rough terrain. Scouts moved in small units called flying columns. Crook served two tours in Arizona, from 1871 to 1875 and from 1882 to 1886. (Courtesy Brady-Handy, Library of Congress.)

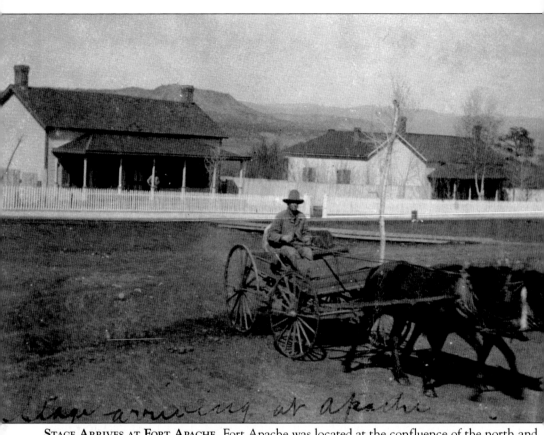

Stage arriving at apache

STAGE ARRIVES AT FORT APACHE. Fort Apache was located at the confluence of the north and east forks of the White River in 1870 to serve as a forward operating base for the cavalry to pursue Tonto and Chiricahua bands that refused to surrender to the Army. The camp was established with a dual purpose: to protect white settlers who were moving into the region from Apache attacks, and to protect the White Mountain Apache people from encroachment by whites. Officially named Fort Apache in 1879, it was one of the most remote posts in the West. Official mail was carried by courier, and regular mail was brought in on a stage like the one pictured. (Courtesy Anne Snoddy-Suguitan.)

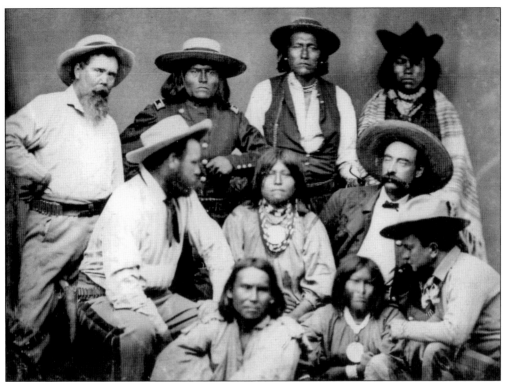

COOLEY AND SCOUTS. Corydon Eliphalet Cooley was a primary force for peace between Apaches and whites in the White Mountains. A first lieutenant in the Union Army during the Civil War, he served with the New Mexico Volunteers as a quartermaster. In Arizona, General Crook hired him as a guide and interpreter for his newly formed Apache Scouts. Cooley befriended Chief Pedro and married two of his daughters, in accordance with Apache custom. Cooley is pictured here at top left. The man with the wide-brimmed hat and mustache is Capt. George M. Randall. (Courtesy Belle Crook Cooley Amos.)

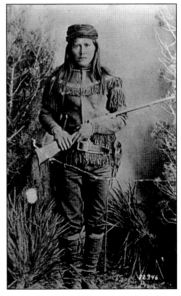

TZOCH "PEACHES," APACHE SCOUT. Some say that the troopers at Fort Apache nicknamed this White Mountain Apache Scout "Peaches" because he was a handsome young man with a "peaches and cream" complexion. He proved to be invaluable in Crook's Sierra Madre campaign against Geronimo's band. Peaches, who had been coerced into fighting with the Chiricahua, was captured without resistance by Crook's White Mountain Apache Scouts. He led them to Geronimo's camp deep within the Sierra Madre of Mexico. When the Apache wars were over, he settled down in Cibecue with his wife's people. In 1933, "Old Man Peaches" was converted to Christianity by Rev. Edgar Guenther and baptized by Evangelical Lutheran pastor Nieman in Cibecue. (Courtesy Ben Wittick, National Archives and Records Administration.)

15

PAYDAY AT FORT APACHE. Cavalry troopers and Apache Scouts collected their pay from the quartermaster's office. Enlisted men earned $13 a month. If they reenlisted for another two years, their pay was raised to $15. The Army had difficulty recruiting men for frontier duty. Although it was dangerous, it offered a safe harbor for those running from the law or domestic problems, those who had lost home and family in the Civil War, and immigrants. When troopers were not in the field, they were laboring at Fort Apache, repairing structures, cutting firewood, hauling water, and building roads. Much of their time was spent grooming, shoeing, and caring for cavalry mounts and training recruits to fight on horseback. (Courtesy Anne Snoddy-Suguitan.)

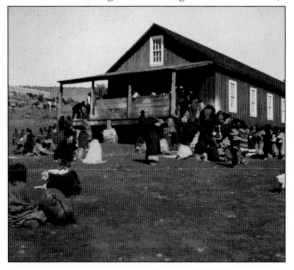

APACHES WAIT FOR RATIONS. Apache families who lived in the area surrounding Fort Apache came into the fort twice a week to get the supplies they were promised by the government. They received rations of beef, corn, beans, sugar, and other staple commodities the government purchased from both white and Apache farmers. Beef was doled out on the hoof. Some Apache families kept their beef cattle instead of eating them and became ranchers themselves. (Courtesy Anne Snoddy-Suguitan.)

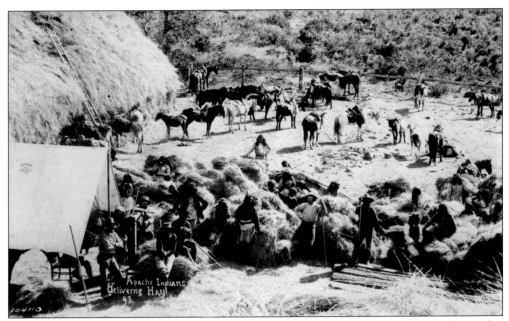

APACHES DELIVERING HAY. Cavalry mounts at Fort Apache needed large amounts of hay. This photograph shows Apaches delivering wild hay to the fort. A large amount of the hay fed to horses was cut by hand from native grasses that grew in abundance on the expansive Bonito Prairie. Schoolteachers cut hay to sell to the government as well, as they were not paid in the summer months when they were not teaching. (Courtesy C.A. Merkey, National Archives and Records Administration.)

CHIEF ALCHESAY. Sgt. William Alchesay (1853–1928) joined the US Indian Scouts at Camp Verde on December 2, 1872. He fought in Gen. George Crook's winter campaign against hostile Apaches in 1872–1873 and was the first White Mountain Apache Scout to receive the Medal of Honor. He also served in Crook's 1885 Geronimo campaign in the Sierra Madre of Mexico, where he tried unsuccessfully to convince Geronimo to surrender. He and Geronimo were lifelong friends. As an influential chief, he traveled to Washington, DC, three times, speaking on behalf of the White Mountain Apache people and meeting with presidents Grover Cleveland, Theodore Roosevelt, and Warren Harding. His nametag (ID) number was A-1. He worked all his life to establish peaceful relations between whites and Apaches. (Courtesy Carl Moon, Wikipedia, Public Domain.)

ALCHESAY IN HIS GOWA. At the conclusion of the Apache wars, Chief Alchesay returned to the White Mountain Apache reservation. His first wife, Apache, bore him a son. He later married Tah-jon-nay and her sister Anna and settled down to farming and cattle ranching on the north fork of the White River. Lutheran missionary Edgar Guenther, who became a blood brother to Alchesay, nursed him back to health during the influenza epidemic of 1918. Pastor Guenther baptized Alchesay and 100 of his band in the Church of the Open Bible, in Whiteriver. The pastor named his son Alchesay Arthur Guenther in honor of his friend. Alchesay died on August 6, 1928. Through the efforts of the Pinetop-Lakeside Veterans of Foreign Wars and the Whiteriver American Legion, an official granite Medal of Honor tombstone engraved in gold was dedicated on July 30, 2005, at his gravesite. (Courtesy Gloria Guenther.)

Two

Ranchers, Roads, and Freighters

The White Mountains remained silent and undisturbed until construction began on Camp Apache in 1870. The most remote Army outpost in the West required tons of hay, grain, and supplies for the troopers and their mounts. Building materials had to be hauled by wagon from Camp Goodwin to the south. The Army was challenged by logistics.

Entrepreneur Solomon Barth and his brothers Nathan and Morris secured a government contract to haul supplies from Dodge City, Kansas, the westernmost railhead, to Camp Apache. Barth wagon trains consisted of up to 38 Murphy wagons, each pulled by eight huge oxen. Their route took them ever so slowly up the Santa Fe Trail, down the Rio Grande Valley, west to Zuni Pueblo, across the Little Colorado River at St. Johns, on to Springerville, over a wide grassy *cienega*, through pine forests, and downhill all the way to Camp Apache. The journey took months, but the Apaches received their first rations on time in June 1870.

Fort Whipple, near Prescott, was the headquarters for the Department of Arizona. Military personnel came to Camp Apache from Yuma, on the Colorado River, going through Fort Whipple, on to Camp Verde, up over the Mogollon Rim, through Sunset Pass to the Little Colorado River, east to Horsehead Crossing (Holbrook), and south 90 miles to Camp Apache. Mail and express came slightly faster, by mounted courier or stage. Officers and their families traveled by Army ambulance.

A few ranchers moved into the White Mountains in the 1870s, drawn by the government's obligation to feed men and horses and dole out rations of beef twice a week to Apache families. When the Atlantic & Pacific Railroad was completed across northern Arizona in 1881–1882, Holbrook became a major shipping point for cattle, sheep, hides, and wool going east, and supplies, equipment, and mercantile goods coming west. The freighting business between Holbrook and Fort Apache prospered.

It was an eight-day round trip from the railhead in Holbrook to Fort Apache in good weather. Drovers earned $1 a day, the same as cowboys. In spite of bad weather, vile road conditions, wagon breakdowns, lame animals, and occasional holdups, freighters were thankful to receive payment from the government in cash, a rare commodity on the frontier. Freighters made three overnight stops, at Snowflake, Show Low, and the Murphy Ranch. There was no Pinetop until 1885.

John William "Johnny" Phipps was ranching about seven miles southeast of Fort Apache in 1881 when a small band of Apaches drove off his livestock and killed Johnny Cowden, an elderly cowboy who was staying at the ranch house. Phipps heard shots as he was coming in and hid in the brush until nightfall. He then rode to the fort, where he stayed for a few years.

In 1885, Phipps moved onto his homestead on top of the Rim. He farmed about 15 acres, built a log cabin grocery store and saloon, and freighted. The "Top of the Pines," as the troopers called it, was a favorite watering hole for enlisted men. One often-told story claims that Pinetop was named for Walt Rigney, Phipps's bartender, who later bought the saloon. Troopers called him "Pinetop" because he had an unruly thatch of red hair on top of his head that resembled a pine tree, or so the story goes.

Another part-time freighter was William "Billy" Scorse, an early resident of Lakeside. Scorse, an Englishman, grew hay and raised sheep on Billy Creek, which was named for him. He sold produce and canned goods, but his most profitable enterprise was his Last Chance Saloon. Scorse probably moved to Lakeside about the same time Phipps came to Pinetop.

Times were about to change. In the mid-1870s, Brigham Young, leader of the Church of Jesus Christ of Latter-day Saints (LDS), embarked upon a plan to colonize the Little Colorado River Valley. Colonists were asked to leave their possessions behind and establish permanent settlements in Arizona. Among the LDS colonists were William Lewis Penrod and his wife, Polly Ann Young. They left Utah in 1878 with two yoke of oxen, a team of horses, nine children, and sufficient supplies to last six months, arriving in Snowflake in 1879 in a blizzard. Penrod found work with Snowflake rancher John Henry Willis, and they lived there for a couple of years.

In 1881, Cooley hired William Penrod to build and operate a mule-powered shingle mill at Show Low. In 1886, Penrod decided to strike out on his own. He moved his family to a mountain meadow within sight of Johnny Phipps's chimney smoke in Pinetop. The Penrods and their children lived in their wagon box until they could build a log cabin. Before long, the Penrods' married children and grandchildren joined them, creating a community of Penrods.

In 1889, Corydon Cooley sold the ranch in Show Low to Huning and moved to a meadow a few miles south of Pinetop, on the reservation where his wife Mollie had grazing rights. He hired William Penrod to build a large, two-story house. The Cooley Ranch became a well-known stopover and forage station for freighters, military personnel, and travelers well into the next century.

Mormon colonists had established communities along the Little Colorado River and Silver Creek drainages by 1890. With freighting to supplement their farming and ranching, they became more prosperous. In the next decade, LDS pioneers looked to the mountains and the headwaters of Show Low Creek.

SHEEPHERDERS. The first stockmen in what is now the Pinetop-Lakeside area were Spanish sheepherders from New Mexico who spent summers in the mountains. Herders were itinerant, moving their flocks continually to new pastures, living in tents, and cooking in the open. Sheep ranching was highly profitable in the latter half of the 1800s, when stock could graze on the public land and wool was in demand worldwide. Many Western stockmen preferred sheep to cattle, as the profit turnover was faster. Ewes had two lambs every year, while cows only had one calf. (Courtesy Navajo County Library District.)

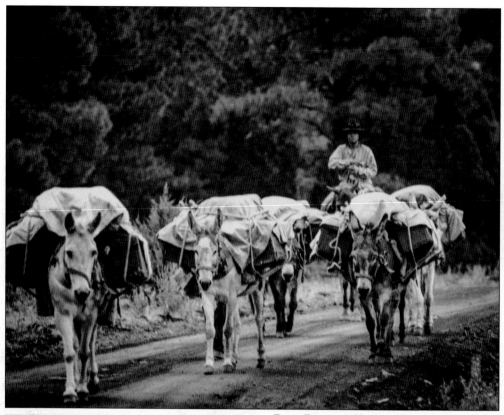

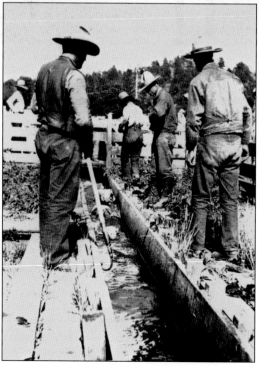

PACK BURROS. Sheep men no longer use the historic Heber-Reno Sheep Driveway to move their bands to the White Mountains in spring and back to the Salt River Valley in the fall. When the trail was in use, herders packed supplies on burros to go from one camp to the next. The *cocinero* went on ahead with the burros so he could prepare a meal and set up camp for the night. This photograph was taken near Los Burros, which is now a national forest campground east of Pinetop-Lakeside. (Courtesy Juliette Aylor.)

TIMBER MESA DIPPING VAT. Sheep owned by Sanford Jaques of Lakeside were dipped in vats in the summer to rid them of parasites. The sheep were driven into a tank full of water mixed with insecticides and fungicides. Men used a plunger to dip them down over their heads, and then allowed them to walk out, have a good shake, and join the band. The dip protected them from fleas, ticks, mites, and flies that carried diseases. (Courtesy Nancy Stone.)

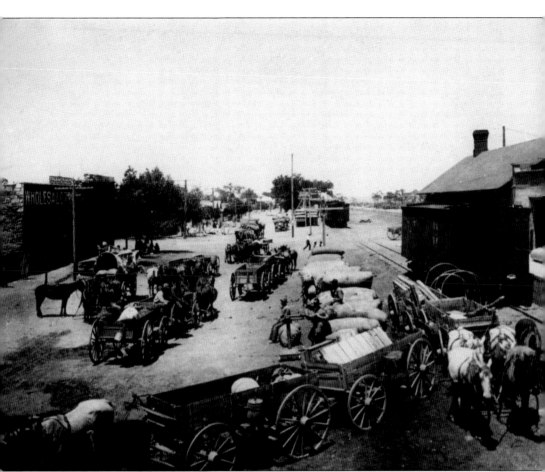

FREIGHT WAGONS AT THE RAILROAD. The Atlantic & Pacific Railroad came to Holbrook in 1881, enabling people in northeastern Arizona to ship goods out and order supplies from the East Coast. Before the railroad arrived, ranchers had to drive cattle to railroad stock pens in Magdalena, New Mexico. Sheep men shipped wool by the ton to woolen mills in the east. Merchandise, hardware, machinery, wagons, and other supplies were shipped in. Many of the early settlers made their living freighting between Holbrook and Fort Apache. (Courtesy Navajo County Library District.)

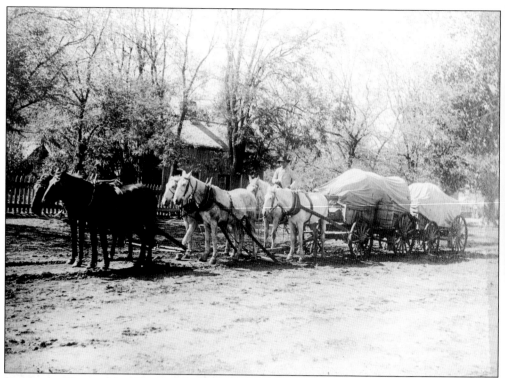

SNOWFLAKE FREIGHTERS. Some of the busiest freight outfits were in Snowflake and Taylor. They shipped hay, grain, corn, beans, sugar, and food staples to Fort Apache for the semiweekly rations provided to Apache people. They also carried household items for officers and their families, as well as mercantile supplies for the post trader. This six-horse outfit belonged to the Hunts of Snowflake. (Courtesy Al Levine.)

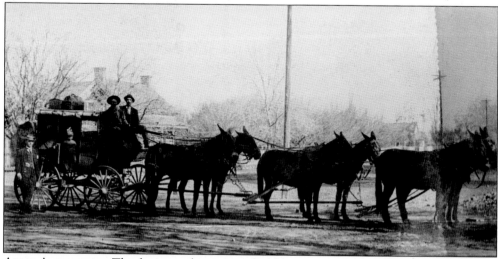

ARMY AMBULANCE. The fastest and most comfortable way to travel in the early days of Fort Apache was by Army ambulance coach. This mule-drawn vehicle was often used to transport Army wives and their voluminous belongings. Author Martha Summerhayes wrote a fascinating account of her journey to Fort Apache by Army ambulance in *Vanished Arizona*. (Courtesy Navajo County Library District.)

Cooley Ranch, 1889. Pinetop pioneer William Penrod and his sons built this spacious home for Corydon Cooley and his wife, Mollie. It was on the main road to Fort Apache, a few miles south of Pinetop. Cooley was known for his jovial hospitality, and Mollie for her cooking and housekeeping skills. The Cooley Ranch was a stopover for travelers between Holbrook and Fort Apache. Cooley provided for man and beast, and also operated a telegraph office. Dances were frequently held for neighbors in Pinetop, Lakeside, and surrounding ranches, with music provided by the Penrod family. (Courtesy Lonnie Amos West.)

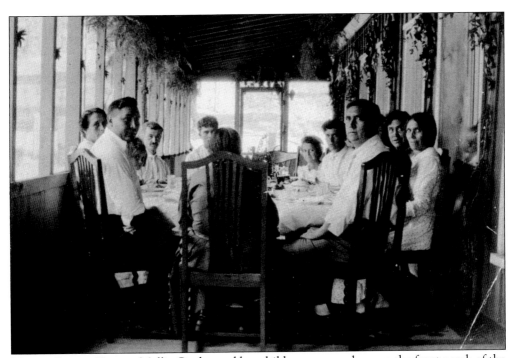

Mollie Cooley Family. Mollie Cooley and her children are seen here on the front porch of the Cooley ranch house in 1919. They are, clockwise from Mollie Cooley, who is sitting at the front end of the table with her back to the camera, Corydon "Don" Cooley, Cora Cooley Pettis, Emily Pettis, Charles Pettis, Roy Pettis, Elsie Amos, Roy Amos, Albert "Bert" Cooley, Belle Crook Cooley Amos, and Charles Cooley. (Courtesy Lonnie Amos West.)

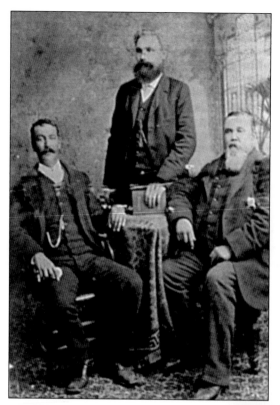

BACA, HUNING, AND COOLEY. This formal portrait of Donicio Baca, Henry Huning, and Corydon E. Cooley may have been taken in 1879 when Apache County was created out of Yavapai County. Cooley is wearing the star he received as a deputy US marshal in 1877. He was elected to the board of supervisors in the first county election. Apache County consisted of approximately 21,000 square miles. It included the White Mountains and all of present-day Navajo County. (Courtesy Show Low Historical Society Museum.)

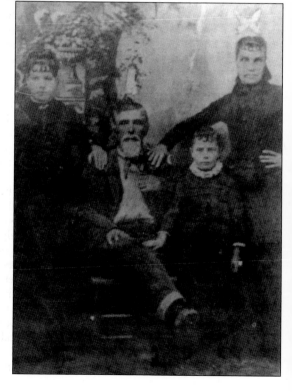

WILLIAM LEWIS PENROD. William Lewis Penrod and his wife, Polly Ann, moved to the Pinetop meadow in September 1886. Penrod was a skilled carpenter. As more settlers arrived from Utah, he and his sons never lacked for business. Historian Leora Shuck wrote that "Susan and husband with three children moved to Pinetop and made their home adjoining their father's place. Then Bert, Del and Eph came with their wives and children. Liola, Liona (twins) and Mayzetta married and lived in Pinetop near their father. Soon he had all his children around him." (Courtesy Navajo County Library District.)

Three

COWBOYS, SHEEPHERDERS, AND FARMERS

Two drinking establishments prospered from the sale of liquor to soldiers from Fort Apache in the 1880s: Johnny Phipps's saloon on "Top of the Pines" and Billy Scorse's Last Chance Saloon, in what is now Lakeside. Drunken brawls were common in Pinetop, especially when soldiers from Fort Apache rode into town.

Enlisted men may have misbehaved at the bar, but local residents seldom complained. Fort Apache continued to be the major source of cash income for both settlers and Apaches. In the 1890s, the post was a proper community, with a school, a hospital, and a library.

Settlers on top of the Rim had none of the luxuries enjoyed by the military. James R. Jennings wrote of a freighting trip to Fort Apache with his father in 1898: "Homes of officers were the ultimate in fine living and elegance . . . The Morgan bred cavalry horses were a sight to behold! The horse barns were always freshly painted and immaculately clean."

Pinetop went through several name changes, including Penrodville and Malpai, referring to the pervasive volcanic rock that made every effort of man and beast difficult. In 1891, the post office was officially named Pinetop, with Edward E. Bradshaw appointed postmaster. There was a one-room store run by a profane bullwhacker named McCoy, a small sawmill, a dance hall, and a saloon.

William Lewis Penrod and his wife, Polly Ann, had 12 children. The Penrods were a lively, hardworking, fun-loving family, each with special abilities. Lakeside historian Leora Schuck wrote, "William Penrod loved sports. He could ride, he could rope, he could take a joke and give one, and he loved music and dancing." His sons John Ralph, Thell, and Arch played the fiddle.

Another early Pinetop settler, John Washington Adair, rode boldly into town in 1895 at the age of 20. He intended to take care of some business, stay overnight, and leave early the next morning. His plans changed, however, when he met Cynthia Jane, the 16-year-old daughter of David Israel Penrod. They were married in Adair's hometown of Kanab, Utah, and returned to live in Pinetop, near her parents and grandparents, where they stayed for the rest of their lives.

Hans Hansen Sr. and his wife, Mary Adsersen, both natives of Denmark, paid Joseph Stock 20 head of cattle for "squatter's rights" to his land and cabin in the little settlement originally called Fairview. Some called it "Hog Town" because of Al Young's hogs, which ran wild in the woods. Latter-day Saints president Jesse M. Smith named the place, more appropriately, Woodland.

The Hansen men were master masons and bricklayers. One day in 1903, Hans and his son Niels stopped at Will Amos's sheep ranch on their way to work at Fort Apache. Amos commissioned them to build an adobe house for his family. Two years later, Niels Hansen bought the house back when Amos decided to move on.

Will Amos's younger brother Abraham Lincoln "Abe" Amos, continued to raise sheep, as his wife had grazing rights on the reservation. He was married to Belle Crook Cooley, one of Corydon Cooley's daughters. Another pioneer settler, Samuel "Ezra" West, and his wife, Julia Ellsworth West, had a son named Earl who married Elsie Amos, the daughter of Abe and Belle Cooley Amos. Intermarriage strengthened the bonds between early settlers.

Pioneer life in Pinetop and Lakeside was one of endless work, but also one of large, close-knit extended families that helped one another. At an elevation of more than 7,000 feet, winters were severe and growing seasons short. Worse, the soil was thin and rocky. Pure spring water and wood for building and heating were plentiful, but rain was unpredictable, so gardens and farms were irrigated from creeks.

Pioneer families ate what they raised, caught, or shot. They kept chickens, sheep, cattle, goats, and hogs, and most had a milk cow. From the earliest age, children were given chores such as gathering eggs, feeding livestock, milking cows, churning butter, hauling water in buckets, and weeding gardens. Boys and some girls learned to ride and shoot almost as soon as they could walk.

Mountain families relied on game and fish to supplement their diet. There were no natural lakes, but trout thrived in the streams. Elk, deer, and wild turkeys were nearly on their doorstep. Large predators like mountain lions, wolves, and black bears took domestic animals at times, but they preyed largely on game. In late summer, women and children gathered wild grapes and raspberries for jam and jelly. Potatoes, turnips, and carrots were preserved all winter in dugouts.

One especially hard winter, the William Penrod family had to feed their corn-husk mattresses to the livestock and sleep in the hayloft. In summer, the Penrod men drove wagons to mountain meadows and cut wild hay for the winter, stopping to hunt on the way home.

In spite of the hardships endured by settlers, romance was always in the air. Marcena Hansen had more on her mind than preserving turnips. Liona "Owen" Penrod escorted her to a Thanksgiving ball at Penrod's dance hall in 1900. To impress her, he drove up in a black buggy pulled by two "shining black horses." She wrote, "He was dressed fit to be a prince for this eventful night." He proposed on the way home.

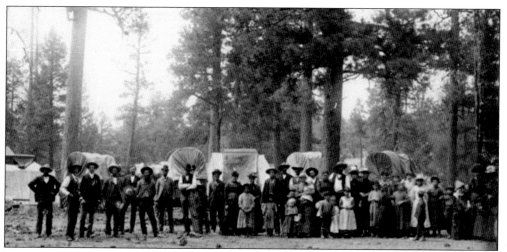

PINETOP CONFERENCE. In 1892, Pinetop hosted a conference for members and leaders of the Church of Jesus Christ of Latter-day Saints. Four Arizona stakes (divisions of the church) were represented: Snowflake, St. Johns, Maricopa, and St. Joseph. More than 1,100 members of the LDS church attended. Meetings focused on problems of land ownership resulting from loans by the church to colonists who came to Arizona Territory. A solution was reached when the LDS Church authorized members to reimburse the church through labor on dams and irrigation canals. Pinetop and Lakeside settlers built a large pavilion for dancing. Church leaders allowed only square dancing during the conference. When they left, it is rumored that local church members stayed up all night "round dancing" under the pines. (Courtesy Snowflake Heritage Foundation.)

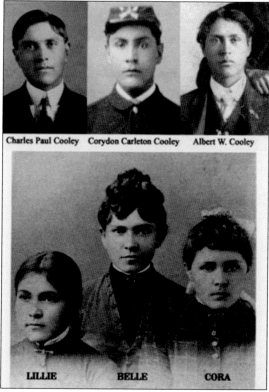

Charles Paul Cooley Corydon Carleton Cooley Albert W. Cooley

LILLIE BELLE CORA

CHILDREN OF CORYDON AND MOLLIE COOLEY. In later years, Corydon Cooley was generally called "Colonel Cooley," a term of respect rather than a military title. Cooley held public offices and continued to serve the military at Fort Apache when called. He and Mollie had five children, all of whom were well educated. Their boys were Charles Paul, Corydon Carleton, and Albert. The girls were Belle and Cora. Lillie was the daughter of Corydon's wife Cora, who died in 1876 of complications following childbirth. (Courtesy Lonnie Amos West.)

JOHN WASHINGTON ADAIR. One of Pinetop's first residents, Adair arrived in Pinetop in 1894 at age 20 and married 16-year-old Cynthia Jane Penrod, the daughter of David Israel Penrod and granddaughter of William Lewis Penrod. (Courtesy Bobbie Stephens Hunt.)

GEORGE AND HARRIET STEPHENS. These early Pinetop residents are seen here on their wedding day in 1907. (Courtesy Lonnie Amos West.)

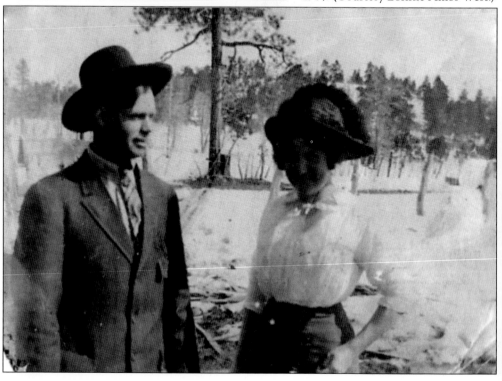

GEORGE STEPHENS AND HIS HORSE FRED.
George Stephens hauled freight to Fort
Apache, usually accompanied by his
wife, Harriet. Their son George Stanley
Stephens was born in a wagon in 1909 on
the road between Pinetop and Fort Apache.
(Courtesy Bobbie Stephens Hunt.)

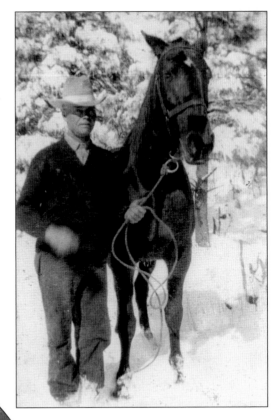

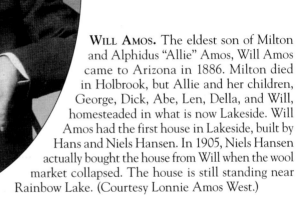

WILL AMOS. The eldest son of Milton
and Alphidus "Allie" Amos, Will Amos
came to Arizona in 1886. Milton died
in Holbrook, but Allie and her children,
George, Dick, Abe, Len, Della, and Will,
homesteaded in what is now Lakeside. Will
Amos had the first house in Lakeside, built by
Hans and Niels Hansen. In 1905, Niels Hansen
actually bought the house from Will when the wool
market collapsed. The house is still standing near
Rainbow Lake. (Courtesy Lonnie Amos West.)

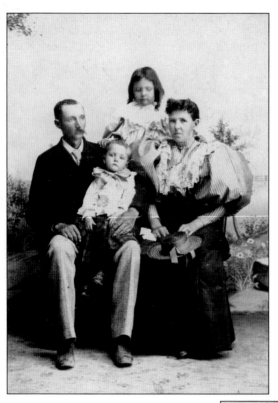

WILL AMOS AND FAMILY. William Nathaniel "Will" Amos, his wife, Carrie, and two of their children are seen here. Will bought land and sheep from men named Kinder and Adamson and settled in Lakeside with his wife. The couple had three children while in Lakeside: Pearl, Willie, and Harley. Will was highly respected as a successful rancher and a good businessman. He and his family left Lakeside in 1905. (Courtesy Lonnie Amos West.)

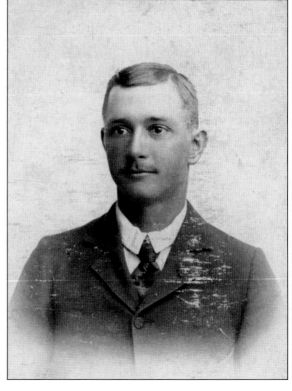

ABE AMOS. Abraham Lincoln "Abe" Amos was a younger brother of Will Amos. His siblings left the White Mountains, but Abe stayed in the sheep business. His wife, Belle, the daughter of Corydon E. Cooley and Mollie, had grazing rights on the Fort Apache Reservation. (Courtesy Lonnie Amos West.)

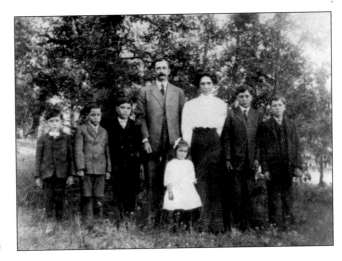

ABE AMOS FAMILY. Abe and Belle Amos made their primary home at what was called the Rock House, on the Fort Apache Reservation between the Cooley Ranch and the Big Spring (located under the Rim; not to be confused with Big Springs in Lakeside). This family photograph was taken in 1909 near the Rock House. From left to right are Tom, Earl, Byde, Abe, Elsie, Belle, Roy, and Paul. Jack and baby George are not shown. (Courtesy Lonnie Amos West.)

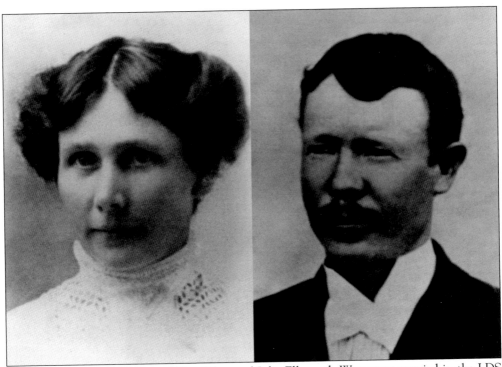

EZRA AND JULIA WEST. Samuel Ezra West and Julia Ellsworth West were married in the LDS temple in St. George, Utah, in 1886. Ezra went into the sheep business, and had a memorable encounter with the Apache Kid and another Apache while he was out in sheep camp in the mountains. The Kid had a price on his head, but Ezra fed them and dressed the Kid's wound, asking no questions. When the wound had healed, the Kid gave him a beautiful pair of beaded moccasins before leaving. (Courtesy Lonnie Amos West.)

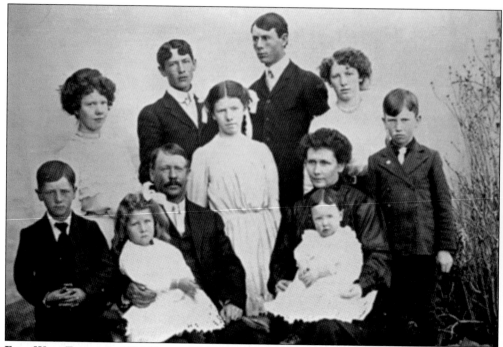

EZRA WEST FAMILY. In 1896, Ezra and Julia West moved their family to Woodland, where Ezra had purchased 160 acres from Abe Amos. They began farming and raised a family of nine children. Julia wrote, "We all helped to clear the stumps, trees and rocks from the land and it is a very good ranch." Julia taught her children to take responsibilities on the farm and at home while their father was away in sheep camp. This photograph was taken in 1909. From left to right are (seated) Mary, Ezra, Julia, and Gwen; (standing) Earl, Emma, Karl, Sedena "Dena," Joe, Ida, and Lavern. (Courtesy Lonnie Amos West.)

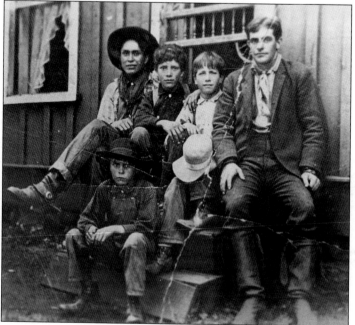

AMOS BOYS. These tough-looking cowboys grew up in the mountains. Pictured at the Cooley Ranch about 1908 are, from left to right, Albert "Bert" Cooley, Roy Amos, Paul Amos, and Charlie Pettis. Sitting in front is Byde Amos. Bert was the son of Corydon and Mollie. Roy, Paul, and Byde were Abe Amos's sons and Cooley's grandsons. Charlie Pettis was married to Corydon and Mollie's daughter Cora. (Courtesy Lonnie Amos West.)

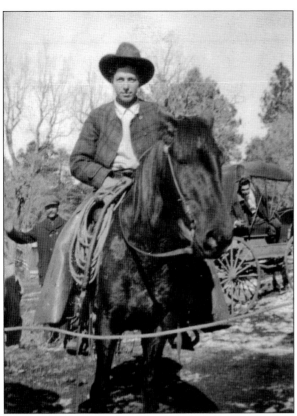

Tom Amos. Abe and Belle Amos's son Tom is seen here in Lakeside. All the Amos boys were good cowboys. Thomas Lavern "Tom" Amos married Elizabeth "Lizzie" Brown, and they had 11 children. (Courtesy Lonnie Amos West.)

Roy Amos. Roy was the oldest child of Abe and Belle Amos. Following in his father's footsteps, he became a sheep man. When he was young, he fell in love with a girl who turned him down. He never married, although he had many friends. In the winter of 1939, he was staying alone at Wilbur's sheep camp near Heber and ran out of supplies. Attempting to walk out, he was caught in a big snowstorm. Sheepherders found his frozen body when they returned to the mountains in the spring. He was 44. (Courtesy Lonnie Amos West.)

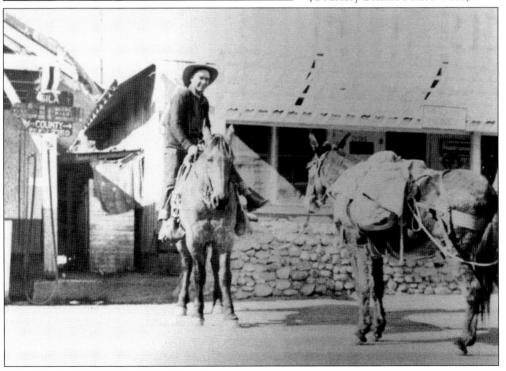

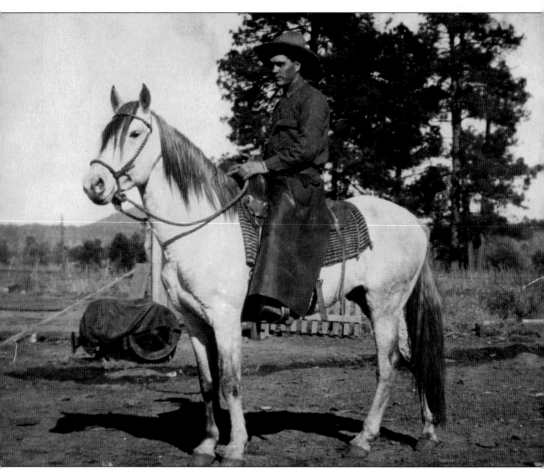

BYDE AMOS. Byron "Byde" William Amos is seen here in batwing chaps putting a rein on a good, stout Buckskin horse about 1920. As a young boy, Byde rode bareback to chase wild horses with his father, Abe, for days at a time. Later, he rode a horse six miles to school in Pinetop every day. As a young cowboy, he was handsome and a good dancer—Bertie Merrill claimed she had danced 100 miles with him. When he was working near Heber, he often rode halfway to Holbrook, where his girlfriend, Maud Gibbons Hanson, taught school at Dry Lake. Byde and Maud were married in 1922 and raised seven children. (Courtesy Lonnie Amos West.)

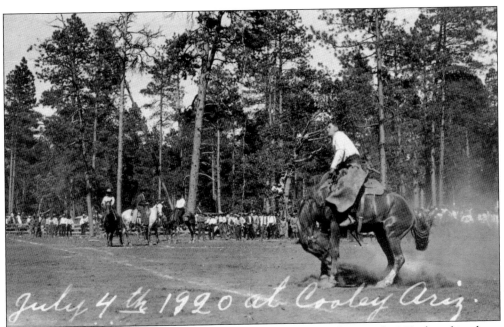

July 4 th 1920 at Cooley Ariz.

EARL AMOS. Cowboys described Earl Logan Amos as "a hell of a bronc rider." His best friend was Earl West, the son of Ezra and Julia West. The boys were swimming in Rainbow Lake one day when they were about 19. Earl Amos had a cramp and started to go under. Earl West swam to help him but was pulled under by his friend's frantic struggling. He managed to break free and made it to the surface, but Earl Amos drowned. Earl West never got over the tragedy, according to his family. He talked about his friend and tended to his grave for the rest of his life. Earl West was married to Earl Amos's sister Elsie. (Courtesy Lonnie Amos West.)

EARL WEST AND DAUGHTER JUNE. Earl West's daughter June seems to be on track to be a cowgirl in this image. He is introducing her to his horse in front of the West Hotel, in Lakeside. Earl loved horses all his life. When he was nine, his parents let him drive a team by himself 60 miles to Holbrook for supplies. He slept out four nights. Too small to remove the collars on the big horses, he just took off the harnesses and back bands for the night and fed them. Men from the mercantile store in Holbrook loaded the wagon for him. As a man, Earl rounded up wild horses and broke them for the big cattle companies. He was also a rodeo bronc rider. (Courtesy Lonnie Amos West.)

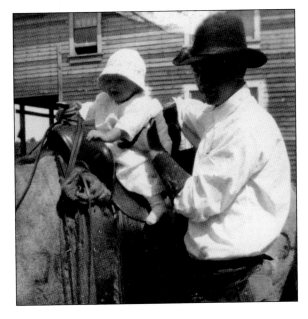

37

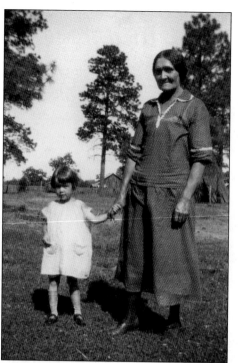

JUNE WEST AND BELLE COOLEY AMOS. June holds hands with her grandmother Belle Crook Cooley Amos. Belle's father, Corydon E. Cooley, gave her the middle name of Crook to honor his old friend Gen. George Crook. The name embarrassed Belle, and she told people her middle name was Lucille. She received a good education at a boarding school in Santa Fe and was an accomplished organist. Like her mother, Mollie, she was a gracious hostess, excellent cook, and hard worker. She lived most of her married life alone with her children on the ranch. A family member said, "She was always good-natured and seemed to have a happy disposition no matter what hardships she faced." In 1935, after 44 years of marriage, Abe and Belle divorced. She went to live with her daughter Elsie and died in Glendale in 1966 at the age of 92. (Courtesy Lonnie Amos West.)

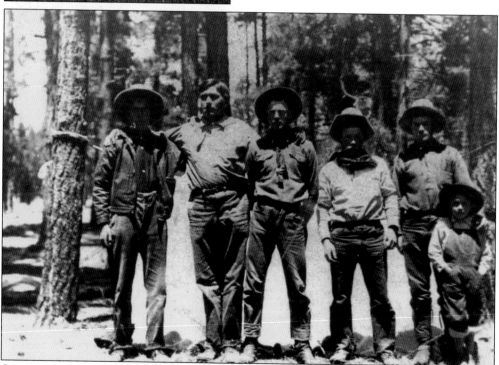

COOLEY'S "HIRED HANDS." Having friends and relatives comes in handy at roundup time, when ranchers helped each other. Here, Corydon Cooley's cowboys are, from left to right, Roy Amos, Charlie Cooley, a man named McBride, Charlie Faught, Charlie Pettis, and "Diddy" Pettis. (Courtesy Navajo County Library District.)

SANFORD JAQUES. Anna Christina Hansen married Sanford Jaques in 1879 in Utah. Jaques was a carpenter and building contractor. He died in 1888 in Tempe, leaving Anna Christina with four small children to support, including Sanford Warren "Santie," "Taddie," and Hans Logan. The widowed Anna Christina moved back to her home in Show Low and married rancher Robert Scott in 1898. They had two children, Hazel and Robert Jr. Anna Christina died in Mesa in 1940. (Courtesy Anne Snoddy-Suguitan.)

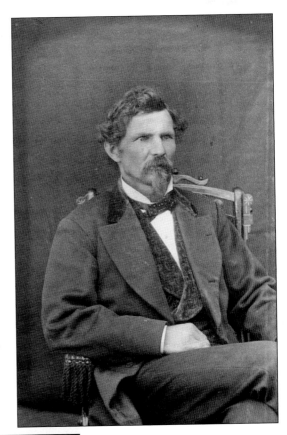

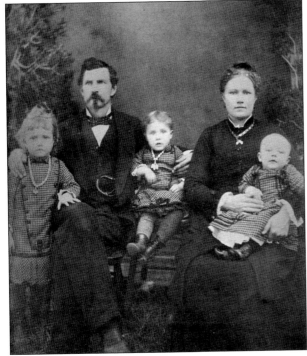

SANFORD JAQUES FAMILY. Seen here from left to right are Anna Christine "Taddie," Sanford, Sarah Jane, Anna Christina, and Sanford "Santie." (Courtesy Anne Snoddy-Suguitan.)

Jaques Ranch House. In 1913, "Sant" Jaques married Beulah Whittamore Jackson, the daughter of a wealthy Kansas City cattle feeder who had acquired the former Jim Porter Ranch in a divorce settlement. Historian Leora Schuck wrote that the house was painted red, with white pillars supporting the front porches. "The great house could be seen looming through sparse trees two miles away, and Lakesiders took pride in pointing it out to visiting friends," she wrote. Sant Jaques ran cattle and sheep on the public domain and reservation. Their Broken Arrow–brand cattle ranged from the White Mountains south of McNary to Cibecue Creek. The ranch was eventually sold to cattleman Maurice Smith. All the buildings burned down in 1953. The 80 acres around the house became part of the Apache-Sitgreaves National Forests in a 1986 land exchange. (Courtesy Myrna Hansen.)

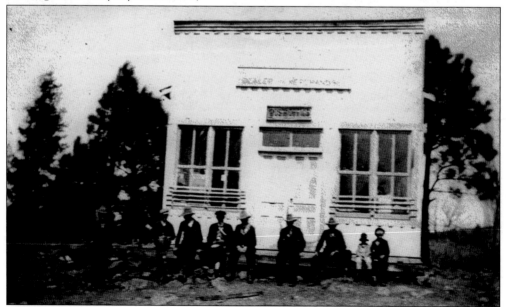

Pinetop Post Office. In 1891, the post office was officially named Pinetop, and Edward E. Bradshaw was appointed postmaster. (Courtesy Sue Penrod.)

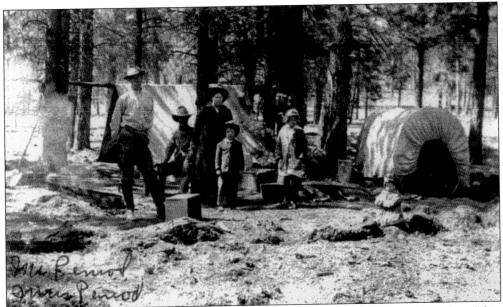

PENROD FAMILY CAMPING TRIP. Pinetop families spent as much time in the woods as they did in town. This family drove to a favorite camping spot in covered wagons and set about getting meat for the winter. (Courtesy Sue Penrod.)

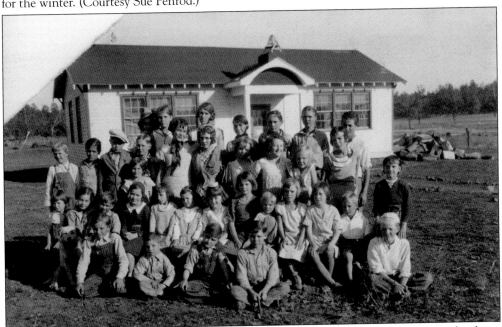

PINETOP SCHOOL. This photograph was probably taken in the 1920s. The one-room school was enlarged as the classes grew. The teacher, Edna Annie Erle Penrod (back row), was from Ohio. At age 26, she took a job teaching school in Pinetop, not knowing where it was. She met Elmer Penrod, who drove the stage from Holbrook to Whiteriver. They were married in 1917 and had one child, Larry Ely. Elmer died in McNary in 1926 of a ruptured appendix. Edna taught in Pinetop, Fort Apache, and Whiteriver for a total of 38 years. Her dog Tippie slept in a box next to her desk. (Courtesy Sue Penrod.)

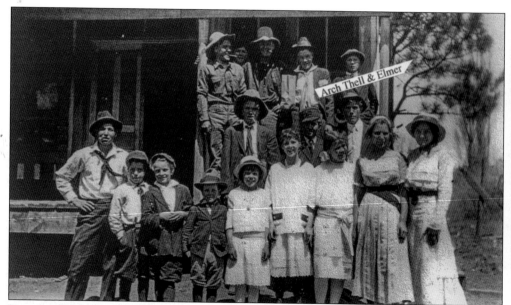

PINETOP OCCASION. The date of this photograph is not known, but it is probably from the early 1900s. It must have been a special occasion, as most of the men are smoking cigars and the women are dressed up. Arch and Thell were sons of William Lewis Penrod, and Elmer Penrod was Eph's son. (Courtesy Sue Penrod.)

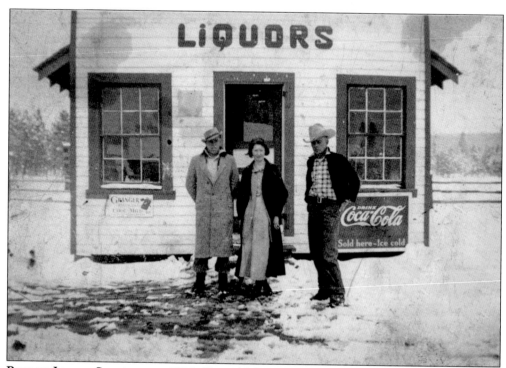

PINETOP LIQUOR STORE ABOUT 1922. "Ice cold Coca-Cola" does not sound very appealing with snow on the ground. (Courtesy Bobbie Stephens Hunt.)

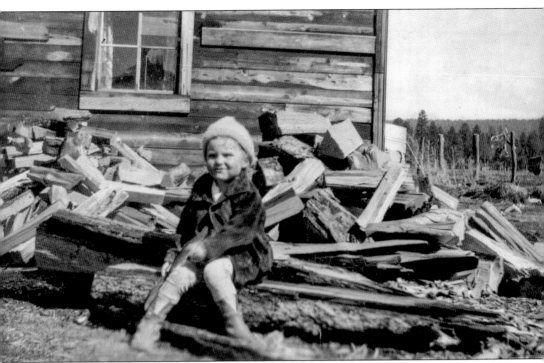

BOBBIE STEPHENS HUNT. Bobbie Hunt sits on a pile of firewood outside her house in Pinetop. She was born in 1934 and grew up during the dark days of the Great Depression and World War II, but always felt blessed to have lived in Arizona's deserts and forests. She and her husband, Arvil Hunt, moved to Heber in 1963, where they raised their five children. Bobbie is the author of books and articles on the people of the Mogollon Rim country. (Courtesy Bobbie Stephens Hunt.)

Fun Fun Fun

Dancing and Roller Skating

AT THE **BLUE MOON FUN HOUSE**

SHOWLOW, ARIZONA

DANCE TO THE MUSIC OF

STANLEY'S BLUE DEMONS

"Rythmn As You Like It"

Nickel Dances EVERY **Wednesday**

9:00 till ?

Big Party Dance EVERY **Saturday**

9:30 till ?

Roller Skating Sun., Mon., Thurs.

AFTERNOONS 2:30 to 4:30 EVENINGS 7:00 to 1 a. m.

Follow the crowd for your fun. Meet your friends there.

Thank you. **TIM RYAN, Manager.**

FUN FUN FUN

BLUE MOON DANCE HALL. In the 1920s and 1930s, young people from Pinetop and Lakeside drove to the famous Blue Moon Dance Hall in Show Low to have a good time. It was owned by Joe West of Lakeside and Stanley Stephens, whose band, Stanley's Blue Demons, played there. Bessie Butler, who married Maurice Penrod, wrote, "What fun we had at the dances there. Mrs. Helen Lonsway was always willing to go along and chaperone us girls." (Courtesy Bobbie Stephens Hunt.)

Four

DAMS, DITCHES, AND LAKES

Early settlers were blessed with natural springs, seeps, and streams, but water rights were not won without a fight. According to Gene Luptak, author of *Top O' the Pines*, Henry Huning filed a complaint against water users upstream from Show Low Creek in 1894, charging that they illegally diverted a tributary of Show Low Creek by means of a dam and ditches.

The trial began in December 1895. To Huning's dismay, the judgment divided water rights equally between litigants on Show Low Creek and its tributaries, giving each party sufficient water for small-scale farming.

Hans Hansen Sr., who settled in Woodland in 1892, had faith that an LDS colony could sustain itself in the mountain country if reservoirs were built. Hans Hansen Jr. and his wife, Loretta Ellsworth, joined his parents in Woodland in 1893. In 1897, Hans Hansen Sr., Hans Hansen Jr., and S.E. Jewell filed the first known notice of appropriation of water from springs in the Pinetop area for the purpose of diverting water to a proposed dam and reservoir. Woodland dam was built.

Hans Hansen Sr. died suddenly in 1901 in Colonia Juarez, an LDS colony in northern Mexico. The following year, Hans Hansen Jr. was called to go on a two-year mission for his church. His wife, known to everyone as "Aunt Retta," continued to run their farm and raise the children while he was gone. To support her family, she took in sewing and washing and boarded the schoolteacher until she found her true calling as a nurse and midwife to all who needed her.

In 1905, Hans's younger brother Niels and his wife, Rosabel "Belle" Gardner Hansen, borrowed money and bought the house Niels had built for Will Amos two years earlier. One day, Niels was showing the settlement to Brigham Young Jr. As they rode across a stream, Young is said to have remarked, "This is a beautiful lake site. A town could be built on either side. What a wonderful place to dwell!" It was a prophetic exclamation.

From 1896 to 1904, Arizona experienced the most severe drought yet recorded, according to the Palmer Drought Severity Index. All the springs on top of the Rim dried up, with the exception of Adair. Clearly, a larger reservoir was needed.

Residents of the new colony negotiated with the Show Low Irrigation Co. to use water from the Adair and Walnut springs for irrigation. In return, they agreed to raise the small existing dam to the 10-foot level. The job was completed by 1910.

Niels Hansen designed and made his own surveying instrument to stake out the main canal that would supply irrigation water from Lakeside Lake (now Rainbow Lake) to farmers and ranchers along Show Low Creek. Skeptical neighbors told him his system would not work because he was "trying to make water run uphill."

Other pioneers involved in water negotiations were John L. Fish, Joseph Peterson, Alof Pratt Larson, John Heber Hansen (no relation to Hans or Niels), and Louis Johnson.

In the early spring of 1906, the six men hunkered down on the sunny side of Niels Hansen's barn, tossed out a few suggestions, and decided unanimously to call their home Lakeside. When the decision was made, Belle Hansen tied a red cloth to a broom handle in lieu of a flag, and waved it in the air shouting "Hurrah for Lakeside!"

An often-told story is that after the naming of the town, Niels Hansen, Joseph Peterson, John L. Fish, and Louis Johnson rode their horses up to Adair Spring, the primary source of their future irrigation water. Peterson offered a toast to Hansen, saying, "Here's to the Mayor of Lakeside," and they all bellied down on the bank to drink a toast with pure, cold spring water.

In October of that year, the US Postal Service hired John L. Fish to serve as the first postmaster of the new town of Lakeside.

Lakeside Lake became the center of activities. Residents cut ice and stored it in sawdust for the summer months in anticipation of ice cream socials. An open pavilion known as the Bowery was built in 1910. It had a plank floor and a roof made of leafy boughs supported by poles. Sunday services were held there before a church was built.

Lakeside pioneers went all-out for the Fourth of July. A barrage of gunfire from ranchers and farmers woke the community at daybreak. Niels Hansen drove a four-horse team pulling a double wagon bed of serenaders. Don L. Hansen said, "Everyone who could sing or thought they could sing crowded in the wagon and rode from one end of town to another singing patriotic songs."

A morning parade was followed by patriotic speeches. In the afternoon, families held a potluck picnic under the pines. Pony races, footraces, and contests of all kinds took place. Swimming and diving competitions and boat races were held on the lakeshore. Local cowboys competed in a rodeo on a flat that became the Lakeside Forest Service campground.

Leora Schuck summed up early life in Lakeside: "The biggest joys of those days was when we met together at church, house parties, celebrations, etc., with a closeness that made us one big family."

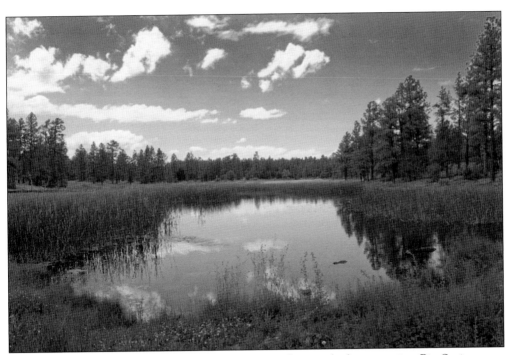

BIG SPRINGS. Sacred to the White Mountain Apache people for centuries, Big Springs was once a gathering place for Apache ceremonies. Big Springs is now part of the Lakeside District of the Apache-Sitgreaves National Forests and is used by the Blue Ridge School District as an environmental study area. (Photograph by Lloyd Pentecost.)

HANS NIELSEN HANSEN. Hans Hansen Sr. was a Danish immigrant living in Utah who responded to pioneering settlement calls from LDS leader Brigham Young. As a missionary, he covered vast distances between Salt Lake City and Mexico. In 1879, he moved to Arizona. Serving as bishop of the LDS Show Low Ward in 1884, he traveled to and from Juniper (Linden) and Fort Apache on a little mule. In 1882, he and his wife, Mary Adsersen, bought land in Woodland from Joseph Stock for 20 head of cattle. His sons joined him in the building trade, and they constructed houses from Snowflake to Fort Apache, many of which are still in use. (Courtesy Anne Snoddy-Suguitan.)

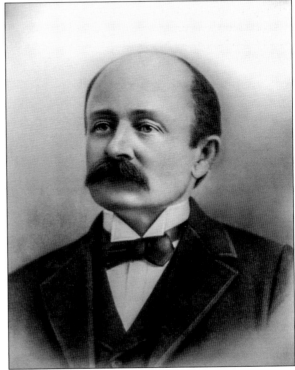

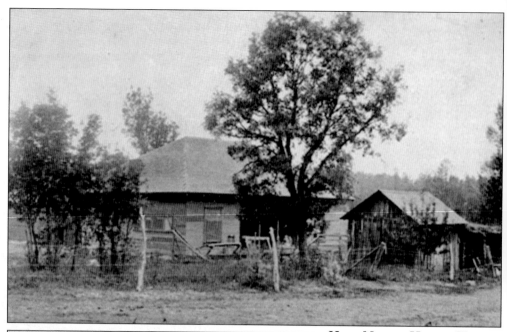

HANS NIELSEN HANSEN HOME. This is a photograph of the Hans Nielsen Hansen home in Woodland. (Courtesy Marion Hansen.)

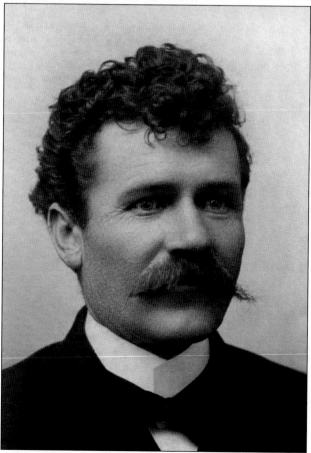

HANS SAMUEL HANSEN, 1902. Hans Hansen Jr. was born in Washington, Utah, in 1862, the son of Hans Hansen Sr. and Mette Adsersen, who died when Hans was two. In 1880, Hans and his sister Anna Jaques and her husband came to Adair, near Show Low. Hans and his father were expert masons, known for using the materials at hand in construction. They made their own plaster of Paris, cement from native clay, and adobe bricks. Hans and Loretta Ellsworth traveled the "Mormon Honeymoon Trail" in a covered wagon and were married in 1885 in the LDS temple at St. George, Utah. Hans devoted his life to his family and community. He died in McNary Hospital in 1953 at age 91. (Courtesy Anne Snoddy-Suguitan.)

LORETTA "RETTA" HANSEN. Like countless other Mormon pioneer women, "Aunt Retta," as she was known, showed her mettle when her husband, Hans, went to Denmark on a two-year mission for his church in 1902. She had grown up on the Ellsworth ranch in Show Low, riding and driving cattle like her brothers. Her husband's absence called for extraordinary strength and self-reliance. By the time Hans returned, she had the respect of all the mountain people for her selfless service as a midwife and nurse. In spite of painful rheumatism, she continued to serve with joy, delivering hundreds of babies, almost until her death in 1940. (Courtesy Nancy Stone.)

NIELS SAMUEL HANSEN. The younger brother of Hans Hansen Jr., Niels Hansen moved in 1906 to Lakeside from Show Low, 14 years after his parents, Hans and Mary, had settled in Woodland. Often called "the Father of Lakeside," Niels was the driving force behind the development of dams and irrigation systems and the man largely responsible for encouraging colonists to come to Lakeside. Historian Leora Schuck remembered, "He was jolly, loved children, frequently carried jelly beans and dimes in his pocket that he surreptitiously . . . handed to some child." (Courtesy Anna Jackson.)

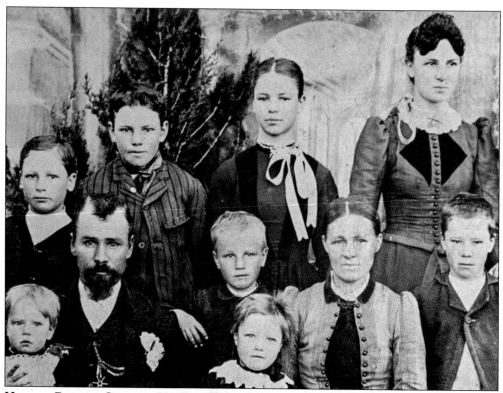

HARRIET ROSABEL GARDNER HANSEN. Pictured here at top right, friends and family called her "Aunt Belle," and she was known for her generosity, hospitality, and miraculous ability to make food stretch for her large family and anyone who ventured by. Leora Schuck wrote, "She cooked great pots of beans and beef and vegetable stews and baked huge batches of bread. She played the piano and taught local children to sing. Both school and church services were held in their home at various times. All the Hansen boys could sing and play instruments; all the girls could sing and play the piano. Aunt Belle lived to see all 11 of her children grown." (Courtesy Renee Penrod.)

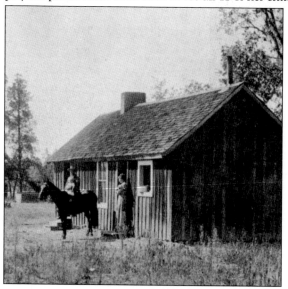

RILEY GARDNER HOME. For pioneer women, life consisted of "goodbyes"— leaving familiar surroundings to travel to an unknown frontier; leaving luxuries, conveniences, and even necessities behind; and leaving a husband who had to work away from home for weeks, months, or years at a time. This photograph is of Riley Gardner's farm. His wife, Frances, is holding a baby while he holds an older child on his saddle. Gardner was a cattleman, cowboy cook, farmer, missionary to the Apaches, and first constable of Pinetop and Lakeside. After raising their nine children, they donated two acres of land to the LDS Church for a cemetery. (Courtesy Marion Hansen.)

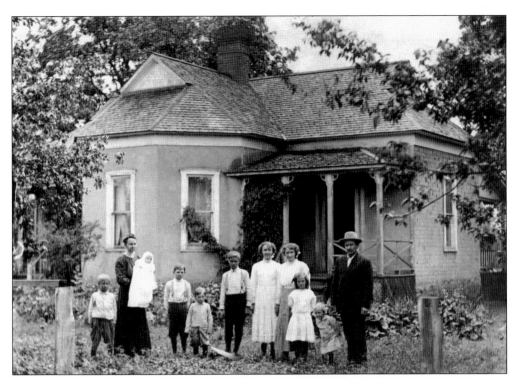

NIELS HANSEN HOME. The Niels Hansen family is seen here in 1910 in front of the home Niels built for Will Amos in 1903 and bought back in 1905. From left to right are Erwin, Rosabel (with baby Charles), Don, George, Junius, Irma, Ernestine, Anna, Marion, and Niels. (Courtesy Marion Hansen.)

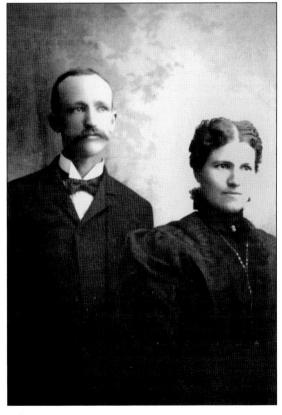

JOHN LAZELLE FISH AND MELVINA CHENEY. John Lazelle Fish was born to a Utah pioneer family. He was one of the six founders of the LDS colony in Lakeside. He married a Pinedale girl named Melvina Cheney in 1888, when he was 20 and she was 15. They lived in Holbrook, where John worked for the Arizona Cooperative Mercantile Institution (ACMI) store. They spent part of each summer in Pinedale so their children could enjoy the mountains. In 1903, Melvina died at Pinedale, leaving John a widower with seven children to raise. (Courtesy Hazel West Fish Gillespie.)

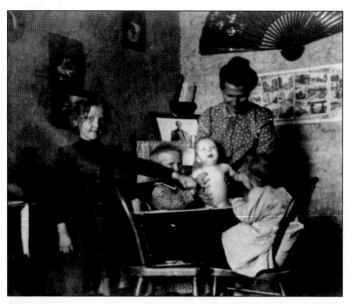

SATURDAY NIGHT BATH. This charming photograph of Melvina Cheney Fish was taken in Holbrook when her husband, John L. Fish, worked at the ACMI store. It is a reminder of the endless chores of a pioneer wife and mother in the days when water had to be heated on a woodstove and children had to take turns bathing in a tub, youngest first. From left to right are Julia, Hamilton Murphy, Ambrose Marion (baby), and Melvina. (Courtesy Hazel West Fish Gillespie.)

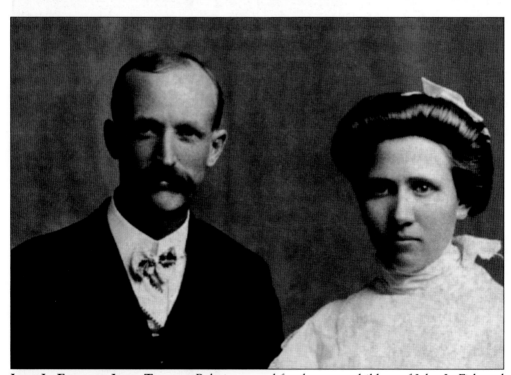

JOHN L. FISH AND JULIA TANNER. Relatives cared for the seven children of John L. Fish and Melvina Cheney when she died. When he married Julia Tanner of Joseph City in 1904, she took on the responsibility cheerfully and had nine children of her own. The family moved to Lakeside in 1906, where he bought a squatter's right from Billy Scorse, which he homesteaded in addition to a large acreage around it. He served his community as the first postmaster, street planner, justice of the peace, health officer, water master, and church leader. He donated part of his land for both a church and a town school. (Courtesy Arlene Fish McCabe.)

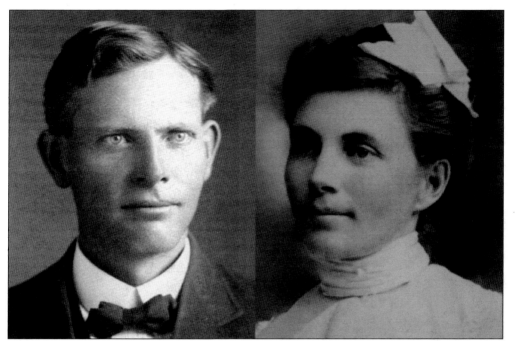

JOSEPH AND AMANDA ANDELIN PETERSON. Joseph Peterson graduated from Brigham Young Academy in Provo, Utah, in 1897, the same year he married Amanda Andelin. The couple moved to Snowflake the following year to organize the new Snowflake Stake Academy. He taught there for eight years, taking off one year for graduate work at the University of California, Berkeley. In 1906, the Petersons moved to Lakeside with Niels Hansen's group, but he continued teaching, encouraging hundreds of young people to strive for a college degree. He also served as a territorial representative, Navajo County school superintendent, and county supervisor. He and Amanda had six children. She died in Holbrook of typhoid in 1919 at age 47. In 1924, Joseph married Lydia Jane Savage Smith. He died in Snowflake in 1943 of lung cancer. (Courtesy Leo Peterson.)

ALOF PRATT AND MARGARET SMITH LARSON. Alof Pratt Larson was born in Snowflake in 1882. In 1904, he married Margaret Smith, a schoolteacher he had been courting for four years. In 1907, they moved to Lakeside and homesteaded on the west side of the lake. Pratt, as he was called, was the first bishop of the Lakeside Ward of the LDS Church, serving from 1912 to 1918. Margaret played the organ for many occasions and was remembered for her popular ice cream socials. Pratt was a surveyor, blacksmith, and carpenter, and set up the first "party line" telephone between Show Low and Lakeside. They kept their land in Lakeside for a summer home but moved to Taylor in 1920. The Larsons served missions to native people on the Navajo, Apache, and Maricopa reservations and in Hawaii. (Courtesy Norma Larson.)

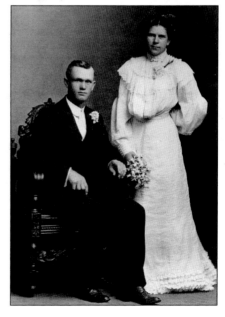

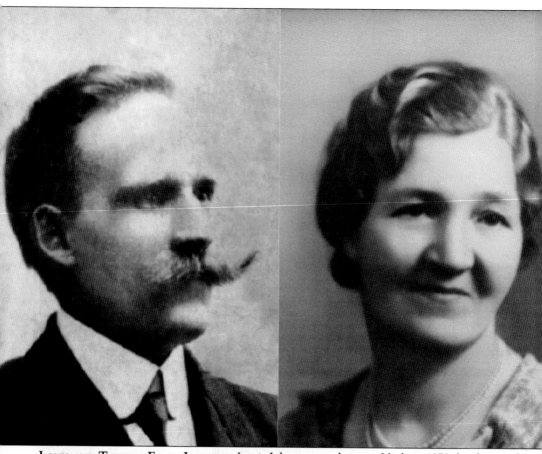

Louis and Theresa Flake Johnson. Louis Johnson was born in Utah in 1872, but his mother and father moved to Pinedale, on the Mogollon Rim, when he was seven. They built a one-room log cabin but ran out of food the first winter. Niels Hansen rode out and gave them flour and salt pork. The following summer, Louis's parents left for New Mexico to work on the railroad that was headed west. Louis lived with the Niels Peterson family for six years. At age 15, he hired on as a cowboy for rancher William J. Flake and boarded with James M. Flake. Flake's daughter Theresa married Louis in 1901, when he was 28 and she was 20. Following the birth of their daughter Lois, Louis went on a two-year mission to Denmark. Theresa moved to Lakeside and cooked for the men who were building the Lakeside dam. When Louis returned, they bought property on both sides of the lake and began farming. Their second child, Anthon Louis, called Tony, was the first child born in Lakeside. The Johnsons had 13 children and raised four grandchildren. Louis died in 1955 at age 82. Theresa died in 1972 at 91. (Courtesy Louise Johnson McCleve.)

JOHN HEBER HANSEN. The oldest of the six founders who named Lakeside, John Heber Hansen was born in Utah in 1859. Tough and self-reliant from a childhood on the frontier, he had little schooling but learned to read and write. At age 20, he was trail boss of an outfit that brought 500 head of cattle, 150 horses, and three emigrant wagons from Utah to central Arizona. Working as a cowboy in the Tonto Basin, he married his boss's daughter, Emily Jennison Fuller, in 1885 in the St. George, Utah, LDS temple. After many moves, they joined Niels Hansen's colonists in Lakeside, living in a tent until he could build a house. Emily died in 1921. John Heber, known as "Uncle Dick" to his many friends, lived alone the rest of his life. He died in 1945 at age 86. He lived a life of danger, adventure, hardship, and, in the end, great satisfaction. (Courtesy Melba M. Gardner.)

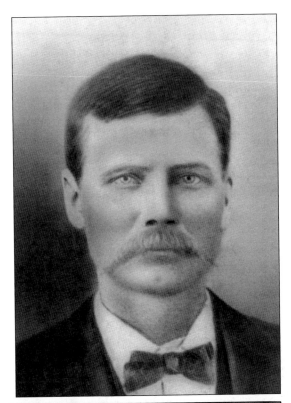

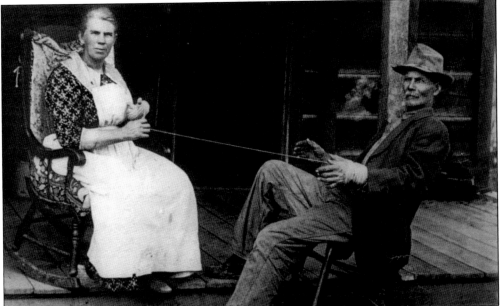

JOHN HEBER HANSEN AND EMILY JENNISON FULLER HANSEN ON THE PORCH. Leora Schuck described Uncle Dick as "Tall, lean, and weather-beaten, he looked the part of the pioneer he was." He may have been as tough as a boot heel, but Uncle Dick did not grumble about helping his wife, Emily, by holding a skein of yarn while she wound it into a ball. They both look the picture of contentment. (Courtesy Craig Hansen.)

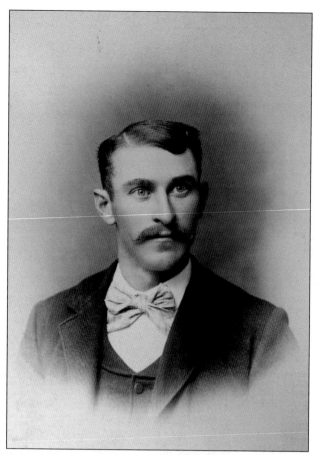

RANCHER GEORGE SCOTT. George Scott was one of the Scott brothers, early-day sheep ranchers on Show Low Creek and its tributaries. The Scotts came from Oregon to Arizona, with Felix arriving in Holbrook first in the late 1870s. Robert and James came about 1878. Robert had several ranches and was known for his hospitality. Among his many friends was Army scout Tom Horn. In 1898, Robert married Anna Christina Hansen of Lakeside, the widow of Sanford Jaques Sr. (Courtesy Nancy Stone.)

WOODLAND SCHOOL STUDENTS. According to a Navajo County semi-centennial program published in 1929, the first classes were taught in Woodland in the winter of 1893–1894 to 10 pupils. By the time this picture was taken, the school population seems to have doubled and added a dog. The first teacher was Sadie Crandall, and the second was a Mrs. Coleman. The teacher on the right is probably Ruby Potter. (Courtesy Nancy Stone.)

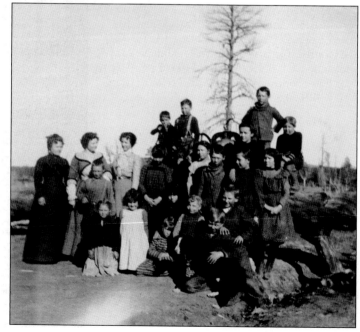

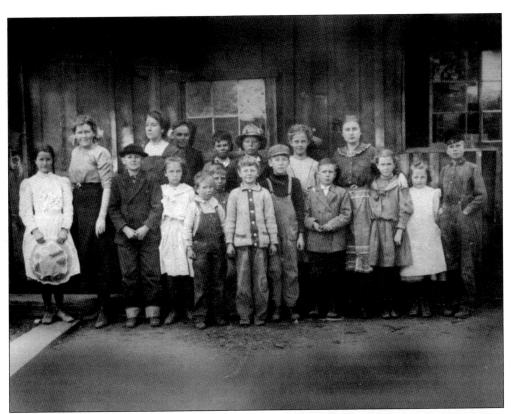

LAKESIDE SCHOOL STUDENTS WITH TEACHERS.
In a history written by Ferrell Fish, he stated,
"Our early pioneers took the education of their
children seriously. The fall of 1906 found them
holding school in Uncle Niels' house with Miss
Lucea Foster as teacher. School was held for
five months that first year with 13 students in
attendance. Classes were moved to Hansen's
bunkhouse for the next five years." (Courtesy
Arlene McCabe.)

SCHOOLTEACHER RUBY POTTER. Ruby Potter
was a pretty lady with many admirers. Her best
beau was John Elam Fish. They were serious
enough to have this portrait taken. (Courtesy
Arlene McCabe.)

"ROUGHING IT." Ruby Potter seems to be slightly unsettled after riding sidesaddle over the malapais and through the mud. (Courtesy Arlene McCabe.)

THE BOWERY. The Bowery was an open-air pavilion with a wooden floor and a roof of boughs supported by poles. Before a church was built, Lakeside colonists held church in the Bowery in summer and in the schoolhouse in winter. (Courtesy Louise Willis Levine.)

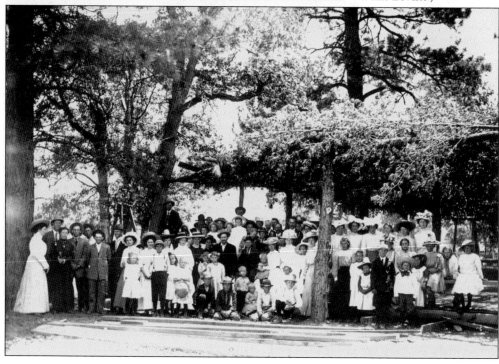

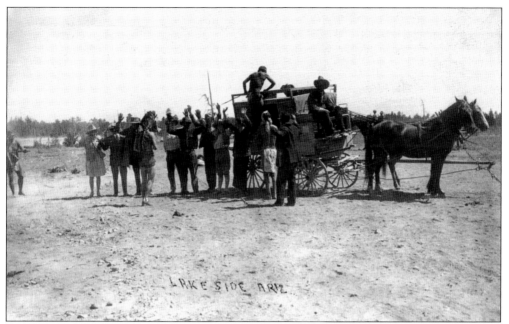

MOCK STAGE ROBBERY. During summer festivals, one of the popular events was a mock holdup put on by local cowboys for the benefit of visitors. White Mountain Apache families drove "up the hill" in wagons for these occasions, setting up camp under the pines, participating in races and rodeos, and even playing the part of "wild Indians" for the stage holdup. At night, the Apache campers would build a bonfire and perform Crown Dances, which white people of that time referred to as "Devil Dances." This photograph was probably taken in the 1920s. (Courtesy Ben Hansen.)

MELODRAMA. Music and drama were part of the summer festivals. This is apparently a melodrama, as the heroine seems to be pleading to the black-hearted villain, "I can't pay the rent." In the center of the back row are Erwin and Don L. Hansen. (Courtesy Ben Hansen.)

FIRST AUTOMOBILE IN LAKESIDE, 1912. Ezra West bought the first automobile in Lakeside. From left to right are "Aunt Retta" Hansen, Earl West, Laverne West, Gertrude Hansen, Mary Hansen, Lamar Ellsworth, Hans Hansen, Ezra West, and Julia West. The girls in front are Mary and Gwen West. (Courtesy Lonnie Amos West.)

WHEN THE COWS COME HOME. Before 1919, Lakeside residents had to milk range cows, the outcome of which was unpredictable and sometimes unproductive. Niels Hansen bought 25 head of purebred Holstein dairy cows and a bull named Jerry in Safford. He drove them over the old military trail through Rice and Cassadore Springs to Fort Apache, then up over the Rim to Lakeside. When a cow became sore-footed, Hansen would split a horseshoe and shoe the cow. With his dairy established, he and his sons sold milk, cheese, butter, and ice cream as well as eggs and vegetables to the people working at the mill in McNary. (Courtesy Ben Hansen.)

PHILE KAY FREIGHT OUTFIT TO FORT APACHE. Philemon Henry Kay was born in Idaho in 1877 and came with his parents to Arizona when he was a year old. In 1907, he married Anna Elizabeth Hansen, the daughter of John Heber and Emily Hansen. To support his family, he had many jobs, including freighting with a team and a wagon between Holbrook and Fort Apache. In 1924, he began hauling freight in a truck. One year, he delivered a load of Christmas gifts for Apache families to the Lutheran church in Whiteriver and was unable to get home when a blizzard closed the road. He had to stay with Rev. Edgar Guenther and his wife, Minnie, so he pitched in. They divided clothing and toys from eastern donors, 100 pounds of mixed nuts, apples, and oranges donated by Holbrook mercantile stores, and ribbon candy from Salt Lake. Phile and the Guenthers made 12 washtubs of popcorn. They filled sacks for the Apache children as well as Phile's family of 12. When Phile saw Reverend Guenther on the next run, he told him it was the best Christmas his family ever had. (Courtesy Guenther Collection.)

THE REV. EDGAR AND MINNIE GUENTHER. Edgar Guenther was a young seminarian at the Wisconsin Evangelical Lutheran Synod Seminary when he learned there was a pastoral vacancy for missionary work among the Apache Indians of Arizona. There was one prerequisite he lacked. The church wanted a married man. Edgar was not even engaged, but he had been seeing a young lady named Minnie Knoop. He showed up on her doorstep as soon as he could get there and asked her if she would marry him and go to Arizona. Without hesitation, she said yes. The young couple traveled by railroad, freight wagon, and buckboard to Fort Apache in 1911. It was the beginning of a lifetime of Christian service to the White Mountain Apache people. With the support of Chief Alchesay and the Apache people, Edgar Guenther established a church, a school, and an orphanage, nursed the sick through the flu epidemic, and ministered to six congregations. Minnie raised their nine children and several Apache children while serving as the church organist and a nurse, teacher, and community leader. She was honored as a national Mother of the Year and is in the Arizona Women's Hall of Fame. (Courtesy Guenther Collection.)

Five

FORESTERS, LOGGERS, AND SAWMILLS

The largest contiguous stand of virgin ponderosa pine in the world hugs the Mogollon Rim for 200 miles from the southeast to the northwest across central Arizona. For centuries, the forest remained pristine. Lightning started fires and rain put them out. Apache people set fires in late fall to burn off forest duff and undergrowth. The low-intensity fires did no harm.

The earliest settlers cut only the timber they needed. When Fort Apache was established in 1871, cavalry troopers cut logs for enlisted men's huts and the commanding officer's quarters. Construction of a post hospital and other buildings required lumber, so the Army built a sawmill.

Settlers had an opportunity to cut, haul, and sell timber for ties when the Atlantic & Pacific Railroad crossed northern Arizona in 1881–1882.

Corydon E. Cooley built a mule-powered shingle mill on Show Low Creek in the early 1880s and hired William Lewis Penrod to run it. In 1886, Penrod moved his family to Pinetop and built his own shingle mill. Shingles sold for $2.50 per 1,000 and were in high demand.

Small portable sawmills began to spring up. Joseph Fish and Joe Kay set up a sawmill on Billy Creek in Lakeside. A Pinetop sawmill was sold to a group of Lakeside men who set it up at Woodland Dam before 1900. In 1911, Mahonri Lazelle Fish bought their mill and spent the remainder of his life in the lumber business. Despite four of his seven mills burning down, he kept going.

Jonathan Henry Webb and his six sons set up 24 sawmills in Arizona at various times. Webb's first sawmill was purchased from the Ellsworth family in Show Low in 1918 and set up at the Webb family ranch between Lakeside and Show Low. Their largest operation was at Vernon, east of Lakeside. These entrepreneurs provided jobs for local people and lumber for construction.

Meanwhile, Washington, DC, was taking a closer look at the consequences of the unregulated consumption of natural resources. As early as 1876, Congress created the Office of Special Agent in the Department of Agriculture to assess the condition of Western forests and prevent their wholesale destruction.

The General Provision Act of 1891 authorized the president to set aside forest reserves. In 1905, the forest reserves were transferred from the Interior Department to the Department of Agriculture and administered by an agency henceforth known as the USDA-Forest Service. Approximately 20 million acres of public lands in New Mexico and Arizona came under regional Forest Service administration.

The decision was a blow to pioneer stockmen. Ranchers who had raised cattle or sheep on the public-domain land and Spanish colonial families who had been in the Southwest for 300 years resented Washington bureaucrats telling them how to manage the land and resources they had husbanded.

Pres. Theodore Roosevelt and his friend Gifford Pinchot, the first Forest Service chief, were well aware of the opposition they would face in their mission to manage national forests on a sustainable basis. Pinchot set down the rule: "Where conflicting interests must be reconciled, the question will always be decided from the standpoint of the greatest good of the greatest number in the long run."

The Apache National Forest was established in 1908. From 1910 to 1912, the timber on both the national forest and the Fort Apache Reservation was inventoried by a group of young Yale University foresters, including Aldo Leopold, author, conservationist, and naturalist.

The nation's demand for lumber increased in the days leading to World War I. Flagstaff businessmen Tom Pollack and A.B. McGaffey eyed the pine belt and borrowed money to build a sawmill and a railroad that connected it to the Holbrook railhead. They purchased 600 million board feet of timber from the Forest Service and the Bureau of Indian Affairs (BIA) and started marking trees for cutting.

Construction began on the Apache Railroad in 1916. Later, railroad spurs were built to remote logging camps. In the beginning, sawmills were set up where the timber was being cut. By 1918, timber was going from the woods to the mill. In 1923, Pollack sold his entire operation to the Cady Lumber Co. of McNary, Louisiana. Cady brought in carloads of experienced workers from its headquarters and built a company town called McNary, after James G. McNary, one of the company partners. The site was leased from the White Mountain Apache Tribe.

The McNary mill was a major economic force in the region, employing up to 750 people. The mill shut down in 1930 when the Depression caused cancellations of lumber orders. The company reorganized as Southwest Forest Mills in 1935. The mill burned down in 1948 but was rebuilt. In 1950, new stockholders changed the name to Southwest Forest Industries. The mill shut down permanently following a 1979 fire. Many McNary residents moved to Pinetop-Lakeside when the mill closed.

Pinetop-Lakeside remains very much a forest community. The Lakeside Ranger District administers 267,000 acres of the Apache-Sitgreaves National Forests. The ranger station has been the center for maps, permits, and information about outdoor recreation for generations.

On the Springer Mountain fire tower, high above the town's noise and traffic, a Forest Service lookout still watches for smoke.

SHINGLE MILL. The first sawmills in the Pinetop-Lakeside area were shingle mills. William Penrod set one up in Pinetop in 1886–1887. They were dangerous machines consisting of a circular saw blade. The operator slid a block of wood over the saw to slice off the shingles. It was an easy way to lose a thumb or finger. (Courtesy Marion Hansen.)

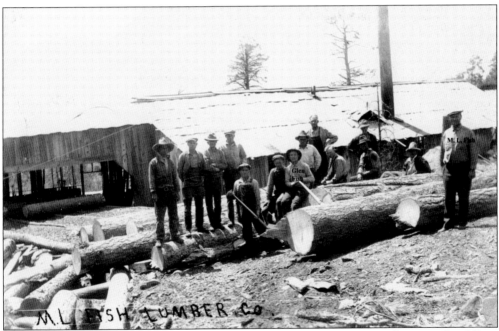

SAWMILL AT WOODLAND DAM. Mahonri Lazelle Fish bought his first sawmill at Woodland Dam in 1911. The old saw frame was part of the sawmill that produced the lumber used to build the LDS temple in St. George, Utah. Nothing was wasted in those days. The mill was dismantled and packed by mule to various settlements in Arizona, with the last parts coming to rest in Lakeside. Sawmills were always at risk for fires and explosions. In 1924, the boiler of this original mill blew up, and in 1928, the roof blew off the building in a cyclone. In June of the same year, Fish lost everything in a fire, including his sawmill, house, and barn. (Courtesy Pam Fish-Tyler.)

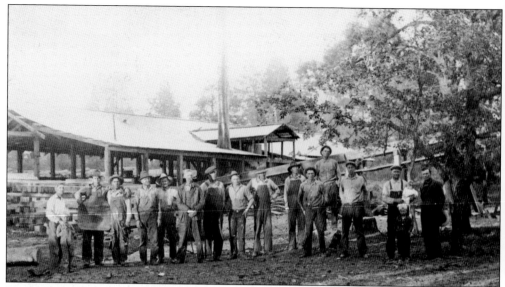

SAWMILL AT WOODLAND ROAD. M.L. Fish and his crew are seen here at a sawmill located off of Woodland Road. Pay slips signed by Fish were used as credit for food at Caldwell's store. In turn, Caldwell was paid in lumber that he exchanged for groceries and other supplies in the Salt River Valley, according to Leora Schuck. M.L. Fish is the man on the left holding a child. (Courtesy Pam Fish-Tyler.)

WEBB SAWMILL CREW. The largest sawmill set up by J.H. Webb & Sons was the Vernon Mill. Shown in this 1938 photograph are, standing from left to right, Tom Frost, Karl Webb, Waldo Ray, Junius Webb, June Webb, Reece Webb, Fred McNeil, and Jay Webb. Ray Webb is in front. In the early days, sawmills were hauled to the timber stand being cut. Later, timber was hauled to the mills by teams, trains, and then trucks. Sawmilling was the driving force of the White Mountains economy for half a century. (Courtesy Webb family.)

ALDO LEOPOLD IN THE WHITE MOUNTAINS, 1912. Leopold's philosophical quest led to the belief in a "land ethic" that evolved over several decades into a system of integrated ecosystem management on federal lands. He is best known for his book *A Sand County Almanac.* (Courtesy USDA-Forest Service.)

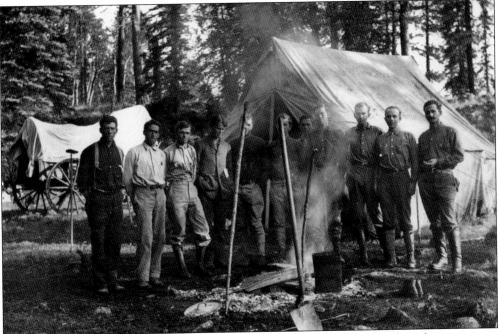

FORESTERS CRUISING TIMBER IN THE WHITE MOUNTAINS. Forestry was a relatively new science in 1910. It began in British Colonial India, where German foresters found ways of preserving valuable teak forests. Germans returned to Europe to teach the "sustained yield" concept. A young American named Gifford Pinchot attended the French National Forestry School and brought his knowledge home. The forests of the White Mountains have always been selectively marked for cutting. (Courtesy USDA-Forest Service.)

Los Burros Ranger Station. The first ranger station in the Lakeside District was constructed in 1909–1910 at Los Burros, east of Pinetop-Lakeside. Approximately 240 acres were set aside for a fireguard, who rode his horse every day to Lake Mountain Lookout, where he climbed a tree to look for fires. If he spotted one, he rode to it and attempted to put it out with hand tools. Los Burros Spring provided water for the fireguard and livestock. (Courtesy Juliette Aylor.)

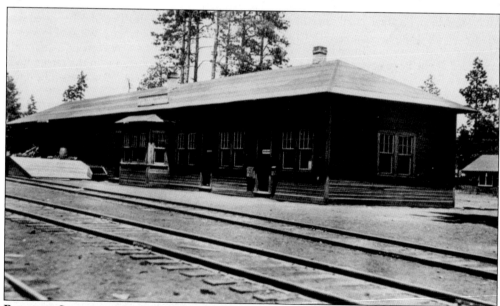

Railroad Station at Cooley. Flagstaff businessmen Tom Pollack and A.B. McGaffey borrowed money from the Atchison, Topeka & Santa Fe (AT&SF) Railroad to build a sawmill and a railroad in the White Mountains. The Apache Railway ran from Holbrook about 70 miles to a place called Cluff Cienega on the Fort Apache Indian Reservation. The town was first called Cooley, after Corydon E. Cooley, whose ranch was nearby. The name was changed to McNary in 1924 after James G. McNary, a partner in the Cady Lumber Co. of Louisiana, which bought the mill from Pollack and McGaffey. (Courtesy Diana Butler.)

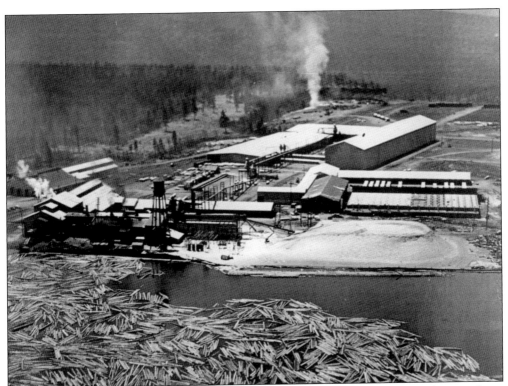

McNary Mill. The first small sawmill was put into operation in 1918. The first log sawed was a ponderosa pine about 2.75 feet in diameter, according to Martha McNary Wilson Chilcote's *Memories of McNary*, published in 1985. As more workers and supplies were brought in, the mill expanded to the large operation shown in this photograph. The millpond is in the foreground. Southwest Forest Mills, under James G. McNary, employed approximately 750 workers. The town of McNary had a population of 2,000 to 3,000. (Courtesy Diana Butler.)

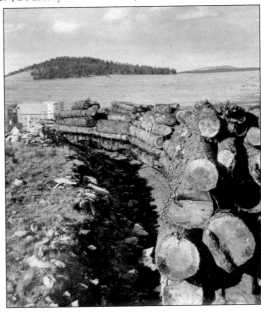

Log Train to McNary. The Apache Railway hauled all the logs from the woods to McNary, and all the finished lumber from the mill to Holbrook to be shipped out on the AT&SF. According to Carl Purkins, the railway ran one train three times a week to Holbrook and a daily log train up to the mountains from McNary. Going up, the train often hauled cinders for road building. Southwest Forest Mills built many miles of logging roads all over the forest, which were used later as fire control roads and for access to hunting and fishing sites. (Courtesy USDA-Forest Service.)

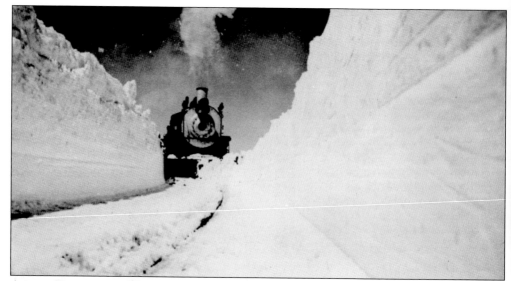

APACHE RAILROAD IN WINTER. The Apache Railroad operated with steam engines at first and then switched to diesel. In summer and fall, the railroad had about 125 employees. When the mill had enough logs on deck to last through the winter, and all the cattle and sheep had been shipped from the high country in the fall, the railroad cut back. Trainmaster Carl Purkins wrote, "In spring . . . we would have to clear the railroad of snow into Big Lake landing and on to Maverick to bring in logs to keep Southwest's big sawmill running." It took up to 10 days to plow the 67 miles to Maverick. In some of the cuts, the snow was 30 feet deep. (Courtesy Diana Butler.)

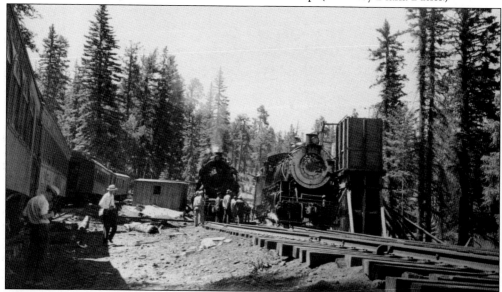

UNLOADING SHACKS. Railroad spurs ran to logging camps throughout the White Mountains and Mogollon Rim, including large camps at Maverick and Standard, near the town of Pinedale. The "crates" being unloaded from flatcars are actually shacks that loggers and their families lived in while they were working in the logwoods. The one-room shacks had woodstoves for heat and cooking. McNary residents Pearl and Ozzie Wilson wrote about one especially bad winter: "The logging shacks at the old camp on Horseshoe Cienega were almost hidden by the snow, with only their stove pipes showing where the camp was located." (Courtesy USDA-Forest Service.)

FALLER WITH CROSSCUT SAW. In the early days, trees were felled with two-man crosscut saws, de-limbed with an axe, secured by chokers on the end of cables, and skidded to a landing by horses. A team of horses loaded the logs one by one onto railroad flatcars that hauled them to the McNary mill. Logging continued through most of the winter in spite of deep snow. One of the fallers joked to Martha McNary that Southwest should pay them by the snow they shoveled, not by the board feet they cut. (Courtesy USDA-Forest Service.)

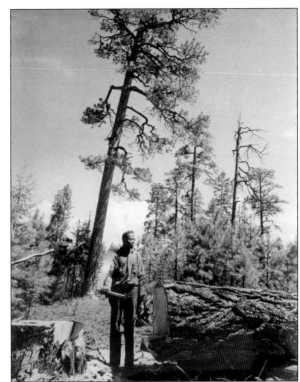

FELLING TIMBER. Some of the early mechanized logging equipment was dangerous. These men are demonstrating the use of a two-man power saw. One man operated a motor mounted on wheels, while the other guided the front of the saw through the log. (Courtesy USDA-Forest Service.)

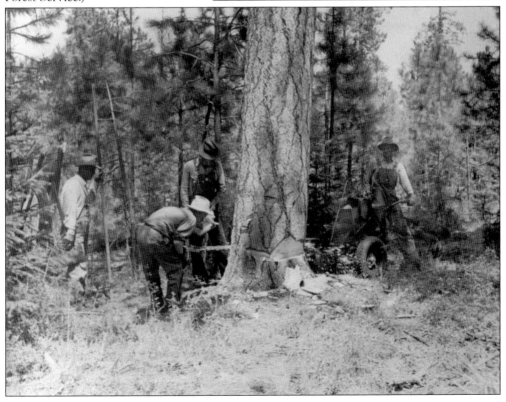

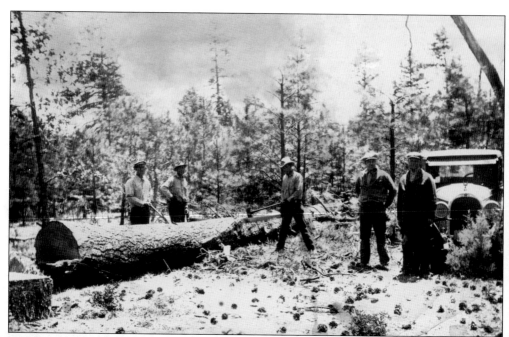

DE-LIMBING LOGS IN WINTER. Logs had to have the limbs cut off before they could be loaded and stacked, as seen here (Courtesy USDA-Forest Service.)

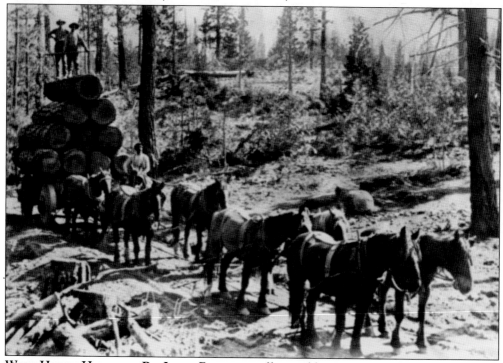

WORK HORSES HAULING A BIG LOAD. Four teams of big workhorses were needed to haul this load of logs from the woods to a railroad spur. When many of the big ranches in northern Arizona sold out in the early 1900s, cowboys and freighters found work with logging companies or with the newly organized Forest Service. (Courtesy Mary Tenney.)

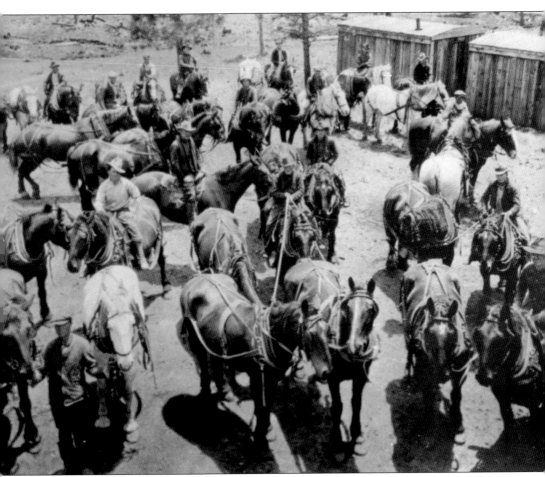

WORK HORSES COMING IN. Horses used for logging were well-trained, disciplined, valuable animals that worked just as hard as their human partners, if not harder. These cowboys are bringing the horses back to camp for a good feed and a night's rest before another day dawns in the logwoods. (Courtesy USDA-Forest Service.)

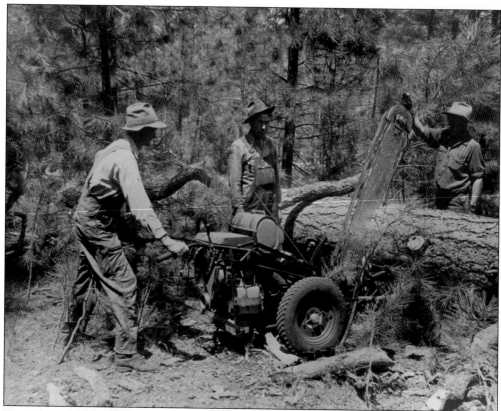

TWO-MAN POWER SAW. These early versions of the chainsaw were used for years, both for felling live trees and cutting timber to size for loading or stacking. (Courtesy USDA-Forest Service.)

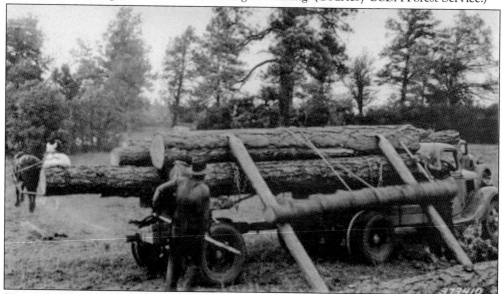

HORSES LOADING LOGS. Horses were used in logging operations even after trucks began hauling logs. Horses could work in steep country and move around in small spaces. This team seems to be pulling logs onto a truck by means of cables and a ramp. (Courtesy USDA-Forest Service.)

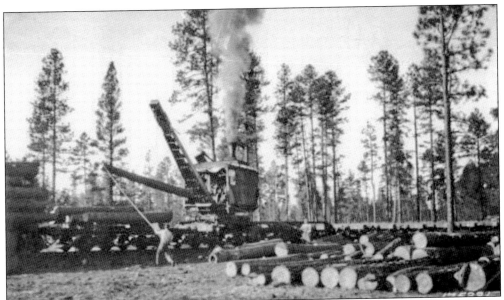

STEAM-POWERED CABLE LOADER. The loader operator had to know how to run the boiler that powered his engine, as well as how to operate the equipment. These men are loading logs from the landing onto flatbed railroad cars. (Courtesy USDA-Forest Service.)

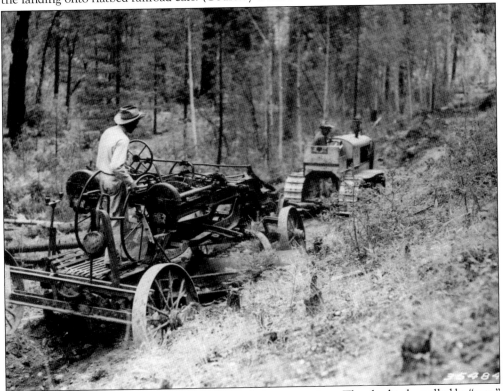

ROAD GRADER. Early road graders did not have their own engines. They had to be pulled by "cats," Caterpillar tractors. One man drove the tractor, while the other steered the grader. (Courtesy USDA-Forest Service.)

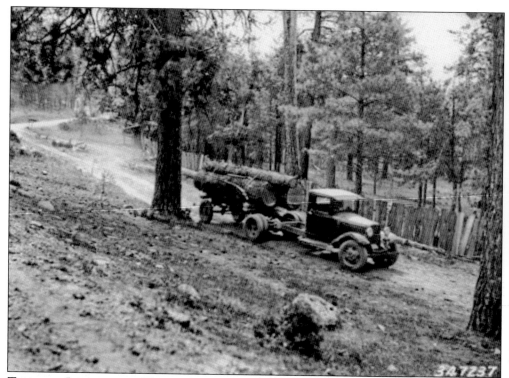

TRUCKING LOGS TO THE MILL. Logging trucks had to handle some steep grades. Southwest used Kenworth and Sterling trucks that could haul as many logs as a railroad flatcar. (Courtesy USDA-Forest Service.)

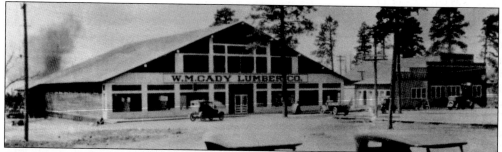

CADY COMPANY STORE. Cady changed the name of the Apache Lumber Co. to Cady Lumber Co., and the town of Cooley to McNary. This is the first company store, which burned down. Employees could charge what they needed through the winter, and it would be taken out of their paychecks when work started up. (Courtesy Diana Butler.)

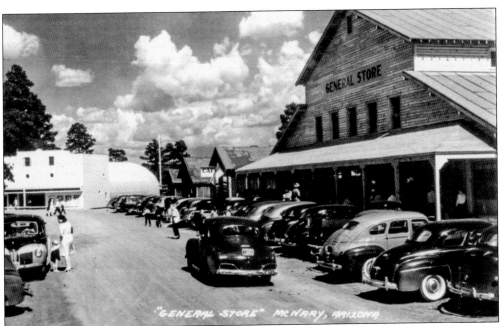

MAIN STREET, MCNARY. McNary was a "metropolis" of more than 2,000 when Pinetop and Lakeside were still mountain hamlets. Planned and built by a Louisiana company, living quarters were as segregated as they were in the South. Spanish and African American "quarters" were down by the millpond. Each had its own elementary school and café. White people lived in company housing on the hill above the mill. Navajo brush cutters and Apache workers had their own villages just over the line in Navajo County. Everyone worked together, went to the same high school, and played on the same teams, but they could not sit together at the movies. Housing segregation continued until the Civil Rights Act of 1964. (Courtesy Diana Butler.)

APACHE HOTEL. The Apache Hotel was built about 1919 and served as a boardinghouse for mill workers as well as visitors. Grayce Quick Peterson managed the hotel and dining room for about 20 years starting in 1945. The hotel was only one of McNary's amenities. The company town had a commissary, offices, a guesthouse for VIPs, a post office, a bank, a café, a garage, a movie theater, a bowling alley, a hospital, a clinic, a fire department, and churches. (Courtesy Diana Butler.)

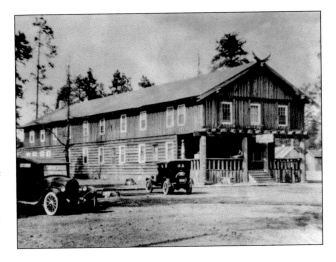

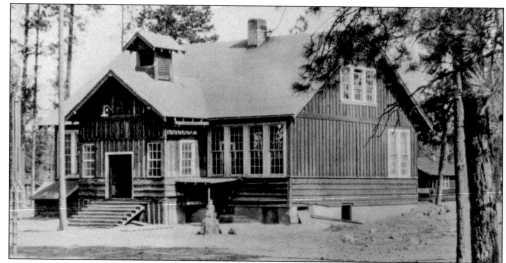

MCNARY SCHOOLHOUSE. The first schoolhouse consisted of four classrooms, with two grades in each room. Later, a high school was built. If children in Pinetop-Lakeside wanted to finish their last two years of high school, they had to choose between McNary and the Snowflake Academy, as there was no high school in either of their communities. The first high school graduating class in Lakeside was in 1932. Rev. Arthur Guenther said, "What really broke down the barrier of segregation was the McNary Green Devils, especially the football and basketball teams." With only 150 high school students, the Green Devils won 85 percent of their games in the 1960s and were undefeated from 1964 to 1966. (Courtesy Diana Butler.)

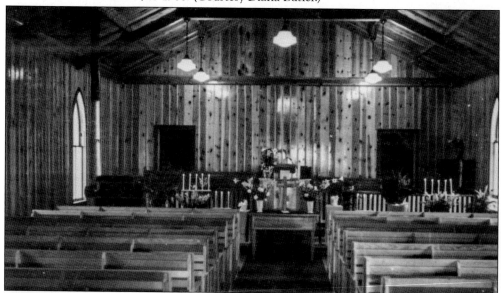

CHAPEL IN THE PINES. A community church called Chapel in the Pines was built in McNary in the late 1930s and used by several denominations. Protestants drove from Pinetop and Lakeside to attend services here until churches were built in their communities. St. Anthony's Catholic Church was the first church built in McNary. Father Augustine, a Franciscan, was the priest in the 1920s and 1930s. There were two Baptist churches in the "Negro Quarters." Lutheran pastor Arthur Guenther held services and Sunday school in Whiteriver, McNary, Maverick, Fort Apache, Springerville, and Show Low. Latter-day Saints missionaries visited homes throughout the area. (Courtesy Diana Butler.)

McNary Hospital. Logging is one of the most dangerous jobs on earth. A company hospital was a necessity for mill workers, loggers, and their families. The McNary clinic and hospital were godsends for the entire region. People came from 100 miles or more to receive medical care. The hospital also helped break down segregation. One of Dr. Arnold Dysterheft's first acts was to have the wall that segregated patients in the waiting room torn down. (Courtesy Georgia Dysterheft.)

McNary Hospital Staff. The McNary Hospital staff is seen here around 1941. From left to right are Dr. Arnold H. Dysterheft, nurse Hilda Mayfield, dentist Dr. Ed Higgins, nurse Zena Higgins, and Dr. Kenneth Herbst. (Courtesy Georgia Dysterheft.)

"Dr. D" Treating a Patient. "Dr. D," as Dr. Arnold Dysterheft was known to the community, treats Wyatt "Dukum" Young in the x-ray department of the McNary clinic. The nurse is Mary Stiles. (Courtesy Georgia Dysterheft.)

Shirley Jones, a Friend to All. Shirley Ann Stratton Jones came from a Show Low pioneer ranching family. She worked as a nurse and nurse practitioner for more than 50 years, mostly in the White Mountains. For the last 30 years of her career, she worked on the White Mountain Apache reservation. A Pinetop resident, she rarely went into a store without stopping to talk to someone she had cared for. (Courtesy Georgia Dysterheft.)

FELLERBUNCHER AT WORK. Logging has come a long way since the early days of two-man crosscut saws, but it is still an important part of the White Mountains economy. This Fellerbuncher can roll through the woods, shear off small-diameter logs at the base, bunch them up, and carry them to a machine that grinds the trees into chips. This monster machine belongs to Future Forest LLC, a business committed to forest restoration. (Courtesy Future Forest.)

FORWARDER. Another heavy equipment giant used by Future Forest is called a Forwarder, a truck that loads itself—a far cry from the days when logs were loaded one at a time by a team of horses. Future Forest works on thinning projects that remove the smaller-diameter trees that act as fuel for wildfires. Thinning provides space for larger ponderosa pines to thrive and grow approximately 300 percent faster. (Courtesy Future Forest.)

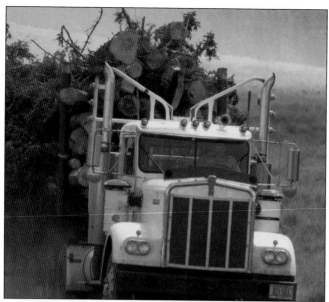

LOG TRUCK. A Kenworth truck is seen coming down off Green's Peak with a load of small-diameter timber. The trees still have the limbs in place so there will be no logging debris on the ground to catch fire. The purpose of thinning is to sustain natural, resilient forests and protect communities like Pinetop-Lakeside from the threat of wildfires. (Courtesy Future Forest.)

CHIP TRUCK. Small trees are fed into a chipper that feeds the chips into a truck bed. The chip truck transports these chips to the Forest Energy Corporation wood pellet plant in Show Low. Rob Davis is the owner and president of Forest Energy Corporation, which manufactures wood pellets for fuel, animal bedding, absorbents, and a five-pound compressed wood log for use in fireplaces and woodstoves. The majority of wood materials used are obtained directly from forest restoration projects. (Courtesy Future Forest.)

Six

HARD TIMES TO GOOD TIMES

As the 20th century dawned, Pinetop and Lakeside were still remote, sparsely populated towns in the midst of a vast pine forest, halfway between Holbrook and Fort Apache. Families made a spare living raising livestock, farming, freighting, sawmilling, or working away from home. Life was good, but making a living was hard.

In 1910, the US Census showed the Lakeside population as 114, and Pinetop as 95. Ranchers in southern Navajo County numbered 52, most of whom were Hispanic sheep men.

The seeds of a recreation-based economy were planted early on. Arizona lawmen took their rifles and packhorses to the White Mountains to hunt deer and turkey when they were tired of hunting outlaws. Outlaws hid out in the mountains when they were tired of being hunted by lawmen. For the most part, they avoided each other, but if an arrest was made, the deputy handcuffed his man to a pine tree and left him there until he was ready to escort him to jail.

In summer, LDS families drove to Lakeside in wagons from Little Colorado River colonies to visit relatives and camp in the cool pines around Rainbow Lake. Townspeople in Holbrook and Winslow called the Mogollon Rim and the White Mountains "Up Country." They considered mountain people a bit rough around the edges, but loved to dance to mountain bands. Pinetop and Lakeside bands were famous. Dances lasted all night, and sometimes all weekend. Cowboys rode in off the range to whoop and stomp at Penrod's dance hall or the Cooley Ranch.

Lakeside pioneer Alof Pratt Larson hauled the first two barrels of rainbow trout fingerlings in a wagon from the railroad in Holbrook to Lakeside in 1909. A procession followed him to the headwaters of the lake, where the tiny fish were turned loose. A few years later, Niels Hansen brought home a couple of small trout he had caught in the lake. His wife, known as "Aunt Belle," fried them and divided them up so everyone at their table could have a taste.

In spite of their relative isolation, Pinetop-Lakeside residents did their part in World War I. Women knit sweaters and socks for the troops. The mountain did not escape the Spanish influenza pandemic of 1918–1919. The flu was rampant on the White Mountain Apache reservation. Rev. Edgar Guenther nursed Chief Alchesay and others back to health with home remedies. His wife, Minnie, cooked gallons of nourishing soup and delivered it by wagon to flu victims in isolated camps.

Schoolteacher A.W. Atherton published a publicity pamphlet in 1918 extolling Lakeside as "a beautiful, wholesome place to live."

Prosperity took hold in the mid-1920s due to the nation's increasing demand for lumber. The Apache Railway and McNary Mill ran at capacity. The lumber business brought in more than 2,000 newcomers and provided jobs for hard-pressed local people. Workers could buy almost everything they needed at the company store—almost.

The 18th Amendment to the US Constitution, passed in 1920, prohibited the production, sale, importation, or transportation of alcoholic beverages. Arizona's territorial legislature had already voted to shut down saloons and breweries in 1915.

Few people in Arizona took Prohibition to heart. There were no speakeasies in the mountains, but hidden in the pinewoods were countless stills for making illegal whiskey. Moonshiners and bootleggers did a land office business in Pinetop until Prohibition was repealed in 1933.

One such entrepreneur was World War I veteran Jake Renfro. He and his wife, Blanche, moved to Pinetop in the 1920s because they both loved to hunt and fish. In addition to making a lot of friends, Jake made "white lightning." When Prohibition was repealed, he pulled two log cabins together and opened a legitimate business he called Jake Renfro's Famous Log Cabin Café. He sold the café to rancher Charlie Clark in 1938. It has been in business ever since under different owners. In addition to food and drink, Charlie's served as a clearinghouse for business deals, politics, news, and fishing information.

Lakeside residents had their own version of good times. The June Moon Water Festival was the biggest event in northern Arizona in 1928. All festivities revolved around the lake. It was Lakeside's first attempt to promote tourism statewide. Activities included the Grand Pioneer Parade, a reenactment of a stagecoach holdup, an all-night Crown Dance by White Mountain Apaches, rodeos, matched horse races, barbecue, watersports, footraces, concerts, and moonlight dances. The Lakeside Pavilion was the largest dance pavilion in the state. The June Moon Festival was highly publicized. People from all over Arizona began coming to Pinetop and Lakeside to fish, hunt, camp, and cool off.

The major obstacle to tourism remained the inaccessibility of the area. Tourists from the Salt River Valley had to drive north to Flagstaff, 100 miles east to Holbrook, and then south 60 miles to Pinetop. People who lived on the mountain usually took a treacherous, narrow dirt road through Whiteriver to get to Globe, Safford, or Phoenix. In 1933, the US Congress funded the Public Works Administration to build a bridge in Salt River Canyon on the White Mountain Apache reservation. The project employed many local workers, including Apaches. In June 1934, access to the White Mountains was shortened with a single-span, steel-arch bridge across the Salt River.

THE WAY IT WAS. In 1900, Pinetop and Lakeside were not much more than wide places on the Holbrook–Fort Apache road. Johnny Phipps and Billy Scorse sold groceries and liquor in their respective stores. William Penrod ran a shingle mill in Pinetop. The first LDS settlers had built Woodland Dam and were working on a bigger dam. Cattle and sheep ranches were sparsely scattered throughout southern Navajo County. (Map by Steve Taylor.)

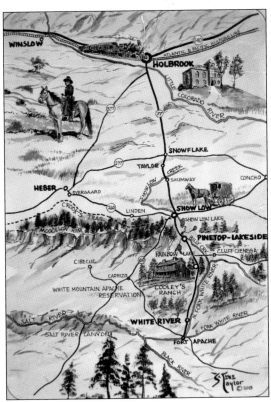

FORT APACHE RANGE ALLOTMENTS. This map from around 1920 shows that most of the rangeland on the White Mountain Apache reservation was being used by non-Indian stockmen from as far away as California. For a grazing fee, large outfits could run thousands of sheep, cattle, horses, and burros on Apache ranges. Leasing by non-Indian stockmen ended in 1930. Finally, in 1953, a Tribal Council ordinance was passed stating that only livestock belonging to a tribal livestock association could graze on the reservation. (Courtesy Dan Carroll.)

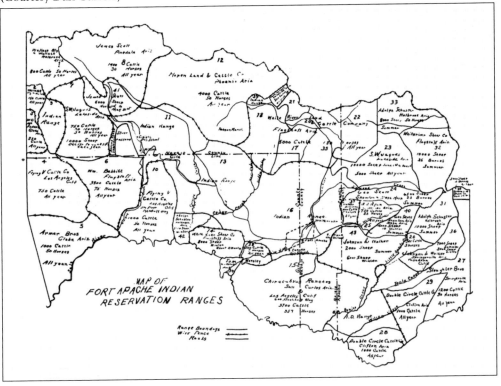

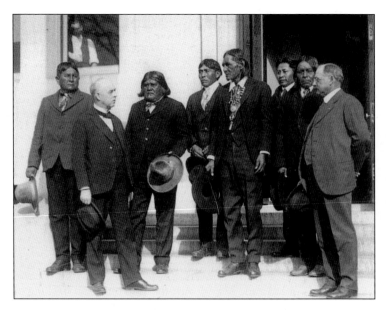

Apache Cattlemen in Washington, c. 1920. Chief William Alchesay, Wallace Altaha, and other Apache cattlemen traveled to Washington, DC, to discuss grazing rights, herd improvement, and range management issues on the White Mountain Apache reservation with US officials. (Courtesy Guenther Collection, Pinetop-Lakeside Historical Society.)

Billy Scorse in 1912. Billy Scorse, an Englishman for whom Billy Creek is named, came to Lakeside in the 1880s. He raised sheep and sold groceries and liquor. Sometime after selling his property to John L. Fish in 1907, Scorse moved to Holbrook, where his brother H.H. Scorse had a mercantile business. Billy is pictured second from the right, with his nephew William and Will's boys Harry and Richard. Billy died on March 24, 1933, in Wilmington, California. (Courtesy Maryann Scorse Coulter.)

THRESHING CREW. All available hands in Lakeside helped with the threshing and stacking of silage in late summer. In rural communities, boys were excused from school to help with farm work. (Courtesy Marion Hansen.)

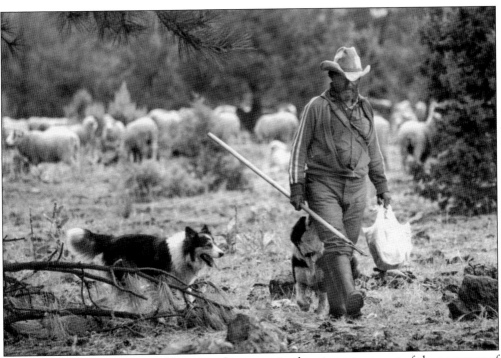

SHEEPHERDER AND PARTNERS. Sheep ranching remained an important part of the economy of the White Mountains in the first half of the 20th century. This photograph was taken in the Apache-Sitgreaves National Forests near Los Burros Campground, east of Lakside, in the 1980s. Sheep wintered in the Salt River Valley and were driven to mountain pastures for the summer by shepherds and their dogs. (Courtesy Juliette Aylor.)

EARL WEST, 1920. West and his pet horse Dollie take time out from cowboying. West was a born horseman who liked to break broncs and train them, as well as ride them in rodeos. In 1916, when he was about 15, he and his brother Lavern caught and broke 125 wild horses for the White River Land & Cattle Co. (Courtesy Lonnie Amos West.)

EARL WEST AND ELSIE AMOS, 1921. Earl West is gallantly tying Elsie Amos's shoelaces on the porch of the West Hotel. Later, they "tied the knot." Elsie was the daughter of Belle Cooley Amos and Abe Amos, and the granddaughter of Corydon Cooley and Mollie. (Courtesy Lonnie Amos West.)

"Held Up On the Way to Church." That was the title of this image in the 1918 Atherton Pamphlet. The people are unidentified, but the man in the big hat is believed to be Frank Owens, a Forest Service district ranger from 1914 to 1919, according to historian Ben Hansen. (Courtesy Marion Hansen.)

West Hotel. In 1914, Lakeside pioneer Ezra West began construction of a large home that would also serve as a hotel. The two-story, 19-room building housed the family upstairs and accommodated guests downstairs. The family had many happy evenings and get-togethers around the fireplace in the big living room. It was the first and last hotel in Lakeside. By the 1930s, most travelers came by automobile and stayed in "auto courts." (Courtesy Lonnie Amos West.)

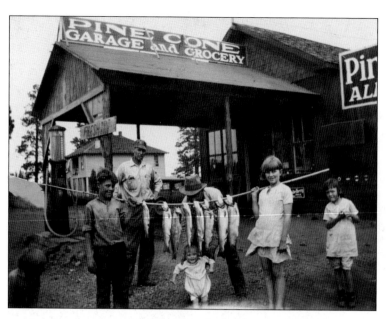

WEST STORE. Ezra West's son Joe built a store next to the West Hotel. The Pine Cone Garage and Grocery were run at various times by Ezra, Karl, Joe, and Lavern West. Here, they are showing off a fine string of trout caught in Rainbow Lake. Lakeside residents were becoming aware of the economic possibilities of tourism. (Courtesy Lonnie Amos West.)

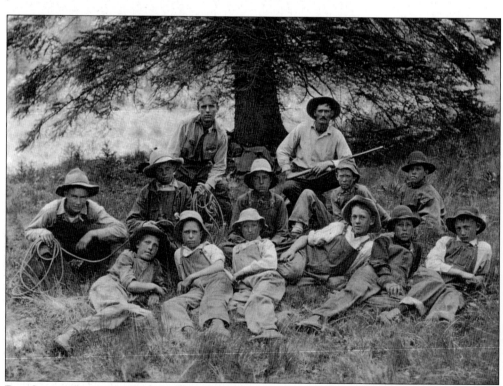

BOY SCOUT TROOP ON MOUNT ORD, 1919. The leader is Phile Kay, in the upper right with the mustache, broad-brimmed hat, and rifle across his lap. From left to right are (lying on the ground) Milton Johnson, Roy Johnson, Rollin Fish, Tony Johnson, Roy Burke, and Dow Rhoton; (kneeling) Lloyd Rhoton, Neil Hansen, Donald Edwards, unidentified, and Lazelle Burke. (Courtesy Marion Hansen.)

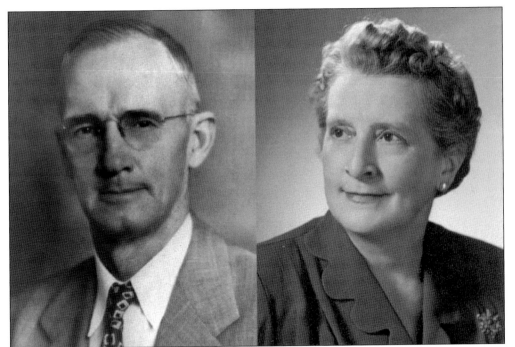

WALLACE AND AUGUSTA LARSON. In 1928, Ezra West, a school trustee, brought in excellent teachers for the little Lakeside school, including Wallace and Augusta "Gussie" Larson. Students could complete 10 grades, but to graduate from high school they had to travel 10 miles to McNary or board in Snowflake for their last two years. The first four-year graduation at Lakeside School took place in 1932. (Courtesy Lonnie Amos West.)

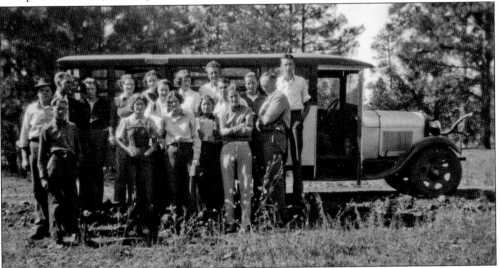

FIRST LAKESIDE SCHOOL BUS, 1937. Lakeside students did not have a school bus until 1937. Having a bus aided the development of sports programs. The first team sport in Lakeside was basketball, with practices held on a dirt court until a concrete pavilion was built next to the LDS church building. Students had no gymnasium until 1954–1955, when a gym was added on to the school building. The original school building burned down in 1957, but the gym was saved. It is presently on the end of the Pinetop-Lakeside town hall. (Courtesy Loretta Lee Jennings.)

JUNE MOON, 1928. These unidentified girls look as if they are still dripping wet. They probably took part in competitive swimming during the June Moon Water Festival of 1928. The festival was the largest in northern Arizona, and the area's first serious attempt to promote tourism. Lakeside was publicized as "The Gardenspot of Arizona, a Paradise, and the Best Place of Outdoor Recreation." All festivities revolved around Rainbow Lake, "the only lake in Arizona devoted solely to the giant Rainbow trout." (Courtesy Marion Hansen.)

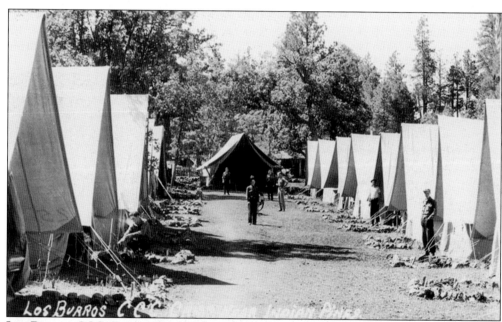

LOS BURROS CCC CAMP, 1933. Author Robert J. Moore wrote in *The Civilian Conservation Corps in Arizona's Rim Country*: "This was camp F-22-A. The medical tent is at the head of the company street in this view." Unmarried men aged 18–25 from all over the United States signed up for the Civilian Conservation Corps (CCC) in 1933. The program was part of Pres. Franklin D. Roosevelt's New Deal, a response to the Great Depression. The program was designed to provide work for the unemployed and promote the conservation of natural resources. Los Burros Camp, one of the first four CCC camps in the Sitgreaves National Forest, was located in a wooded area south of Pinetop formerly known as the Welch Ranch. The CCC camp is not to be confused with a national forest campground also named Los Burros. (Courtesy Marshall Wood.)

CCC Building Fence. The Los Burros fence-cutting crew is building a fence for Lakeside Campground, across from the Lakeside Ranger Station. The CCC crews built forest roads and telephone lines to ranger stations and lookout towers. They also improved the old General Crook Trail (FR 300). They poured concrete for trout-rearing ponds at the Pinetop Fish Hatchery. At one point, the timber stand improvement crew of Company 823 was asked to supply peeled timber for the reconstruction of the Pueblo Ruins at Kinishba, near Fort Apache on the White Mountain Apache reservation. (Courtesy Marshall Wood.)

CCC Mess Hall, Los Burros. The first mess hall for Camp F-22-A was hastily constructed in the summer of 1933. Marshall Wood, who worked at the camp, remembered the room as "primitive and drafty." He explained the after-meal routine to author Robert Moore: "Mess kits were scraped clean in a barrel, then washed through near-boiling soapy water before rinsing in hot clear water." (Courtesy Marshall Wood.)

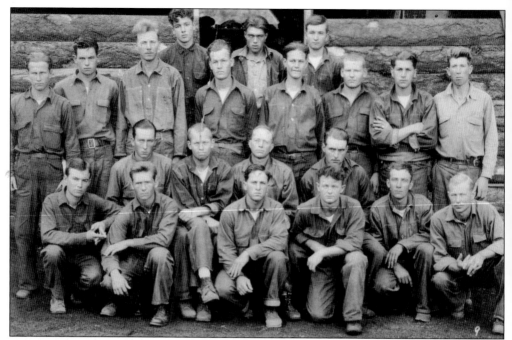

SATURDAY AT CCC CAMP. Men line up for a group shot on a Saturday morning in October 1933 in front of the company canteen. The man on the right is a Forest Service employee. In exchange for labor, men received food, clothing, shelter, and a monthly wage of $30, of which $25 had to go to a dependent family member of theirs. Los Burros CCC Camp was built on the present site of the White Mountain Country Club. (Courtesy Marshall Wood.)

PINETOP FISH HATCHERY. The native fish population of the White Mountains, depleted by early settlers and soldiers, was a concern to territorial leaders who formed the Arizona Fish Commission in 1881. By 1929, the Fish Commission had evolved into the Arizona Game and Fish Department, which has legislative authority to regulate hunting and fishing activities. In the 1920s, the state began building hatcheries and planting trout. About 1932, a new hatchery was completed in Pinetop that became the major trout hatchery and rearing station for Arizona. (Courtesy Arizona Game and Fish Department.)

HATCHERY RACEWAYS. An ample supply of 52-degree water from Pinetop Spring allowed this facility to hatch up to three million eggs a year. Trout eggs were shipped in from as far as Yellowstone National Park. Most trout in the 1930s were reared to about five inches before they were planted in streams and lakes. Too many small trout did not survive, so larger trout were then grown before release. In 1941 the department began planting only creel-sized fish. Unfortunately, the water supply failed in the 1954 drought, and the department closed the Pinetop Hatchery. The redbrick building still stands near the Pinetop Regional Game and Fish Department Office. (Courtesy Arizona Game and Fish Department.)

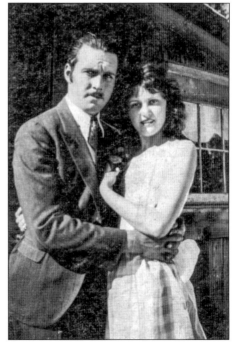

STAN AND MART, 1931. George Stanley Stephens, son of Pinetop pioneers George and Harriet Stephens, was born in 1909 in a wagon while his dad was freighting between Pinetop and Fort Apache. He learned Apache and English simultaneously, growing up with Apache kids. He worked as a logger and then moved to Phoenix to try his hand at music. He could sing, yodel, and play the guitar, banjo, and fiddle. On Radio Station KOOL, he was known as "Mountain Steve." Martha Elizabeth Welmon, known as "Mart," fell in love with his voice. He married her in 1931 and brought her back to the mountains, where they raised their family. (Courtesy Bobbie Stephens Hunt.)

BOBBIE STEPHENS HUNT. Bobbie Stephens Hunt grew up in Pinetop and later moved to Maverick logging camp, where she met Arvil Hunt, an Oklahoma cowboy turned logger. On their first date, she playfully grabbed his new black Stetson hat. He warned, "You don't mess with a cowboy's hat." She threw it in the log pond, so he threw her in the pond. They made up and have been married for more than 60 years. (Courtesy Bobbie Stephens Hunt.)

JAKE AND BLANCHE RENFRO. Ralph Thurston Renfro, nicknamed "Jake," suffered all his life from the mustard gas he received serving in France in World War I. Sent to the Denver Veterans Hospital, he fell in love with his nurse. He and Blanche Ione Sanford were married and eventually settled in Pinetop, as they both loved the outdoors. During Prohibition, Jake, like many others, made and sold moonshine whiskey. With the repeal of Prohibition in 1933, he opened Jake Renfro's Famous Log Cabin Café. Blanche did most of the cooking, and Jake did most of the fishing, so she said. They were known for sharing whatever they had with anyone in need. When a plane crashed on Mount Baldy, Jake and Blanche set up a base camp and cooked for the rescue party. In 1938, they sold the café to Charlie Clark. Jake died in Ajo in 1951 of a brain tumor and is buried in the Pinetop Cemetery. (Courtesy Gary Renfro.)

TURKEY HUNTERS. Local people as well as visitors have always come to Pinetop-Lakeside during hunting season. Holding their Thanksgiving dinners in front of Lisonbee's store and gas station in Lakeside are, from left to right, Gilmore Jackson, Marion Hansen, and Gene Hansen. (Courtesy Renee Penrod.)

CHARLIE CLARK. Charlie Clark's was a one-man operation much of the time, although he did have help from his daughters "Buddy" and "Dolly" when they were not in school. Buddy said they cleaned, washed dishes, and served food but were not allowed to serve liquor. One of her jobs was to roll quarters for customers who played the slot machines. Over the years, Charlie remodeled the restaurant, but he left the legendary barrel from which Jake Renfro pumped "white lightning" buried somewhere under the floor. (Courtesy Bill Gibson.)

CHARLIE CLARK'S IN WINTER. Pinetop winters are not for sissies, but customers could always find a warm fire and warm welcome at Charlie Clark's. By the 1950s, people who had never heard of Pinetop had heard of Charlie Clark's, the oldest continually operating restaurant in Pinetop-Lakeside. Charlie passed on in April 1952. (Courtesy Bill Gibson.)

KIDS ON FLUME. The main irrigation ditch from Rainbow Lake to Show Low ran behind a ranch house belonging to Sanford Jaques. He built a flume to his house from the main ditch that brought freshwater to the house and made a swimming hole for kids. Jim Finney's family lived there in 1939. Sitting on the edge of the flume with their feet in the water are, from left to right, Jack Cooper, Neil Finney, Annie Jo Finney, Hoax Cooper, and Scott Finney. (Courtesy Jo Ann Finney Hatch.)

Seven

GROWTH, DEVELOPMENT, AND INCORPORATION

Throughout the Roaring Twenties, Lakeside remained conservative and rural in nature. Pinetop was "wide open" to gamblers, moonshiners, and bootleggers. Following the repeal of Prohibition in 1933, Pinetop's bars and restaurants came into their own. The best known were Charlie Clark's, famous for steaks; Walsh Mack's Dew Drop Inn, famous for Louisiana-style barbecued ribs; and Charlene Penrod's Ponderosa Club, famous for Western dance bands.

Family businesses sprouted along the highway, including lumber, hardware, and grocery stores, filling stations, cafés, rental cabins, barbershops, realty offices, sporting goods stores, and more. In 1960, Tilden Wilbur built Ponderosa Plaza, the first modern shopping center in Pinetop.

Because of the seasonal nature of work in the woods, local stores let families charge goods in winter and pay their bills when logging started up. Some businesses closed from October until April. The streets "rolled up" at dark, and the only noise at night was from logging trucks going down the one highway through town.

The first bank in the area was in Cooley, which became McNary. It was robbed around 1920 by an outlaw named Oscar Schultz. He locked Bill Hockenhall in the vault and rode off with the contents. Apache County deputy John Earl and posse member Ed Cole tracked him for days until they caught up with him on the Blue River, shooting him and recovering the money. The body proved too heavy for the poor mule, so they buried Schulz along the trail. There was no bank in Pinetop until 1963.

The only telephone lines were private, mail-order contraptions until Lloyd C. Henning of Holbrook started a telephone company. Two lines ran from McNary, one that served the mill and one that went through Pinetop, Lakeside, Snowflake, and Show Low, connecting to the long-distance exchange in Holbrook. McNary operators Melba Butler and Ethel Burke were known locally as the "Hello Girls." Samuel and Stella Yoder ran the Pinetop switchboard. "Grannie" Yoder retired when dial phones were installed.

Residents heated their homes with wood and lighted them with kerosene until 1936, when the White Mountain Electric Cooperative was funded through the federal Rural Electrification Administration. In 1946, the Navopache Electric Cooperative (NEC) was organized. The first power source was the plant in McNary that burned waste products from the mill to create electricity. The emergence of coal-fired power plants and computer technology enabled further

expansion in the 1980s and 1990s. By 2000, NEC served thousands of rural members over a 10,000-square-mile territory.

The Forest Service played a major role in the economic progress of the Pinetop-Lakeside area by developing campgrounds, roads, and recreation sites. In 1954, the Forest Service approved the first nine holes of a golf course in the forest surrounding the former CCC camp. The White Mountain Country Club land exchange was completed in 1968, and now operates as a private, member-owned club.

Pinetop realtor and developer Bob Fernandez began his career with money he won shooting craps in the Army Air Corps in World War II and his wife's savings as an Army nurse. Bob's Realty, an unimpressive log cabin, was in business from 1960 to 2006. Always a gambler, Bob developed subdivisions, RV parks, and a financial center, sometimes operating a backhoe himself. In 1967, Bob and his wife, Jean, formed the FLEX Corporation to negotiate federal land exchanges throughout the West. Fernandez was the key player in developing Pinetop Country Club.

Since pioneer days, residents have been committed to education. Wallace and Augusta Larson were both educators who also served as state legislators and fought for better funding for rural schools. Lakeside's first four-year high school class graduated in 1932. In the 1940s, Pinetop and Lakeside schools were consolidated into the Blue Ridge Unified School District, with an elementary school, a middle school, a junior high school, and a high school.

The first Blue Ridge football team was fielded in 1951, with principal "Pa" Larson buying uniforms. Nearly all the high school boys had to play football for the school to field a full team. They chose Yellow Jackets as their name in 1957. Since then, the mighty Blue Ridge Yellow Jackets regularly win regional and state championships in both sports and academic competitions.

By the 1970s, it had become obvious to a few people that Pinetop and Lakeside needed to merge into one town if they wanted to grow. Navajo County, one of the poorest in the state, could not provide needed services. In addition, the rival town of Show Low was planning to annex land adjacent to Lakeside, which would have limited future expansion. Neither Pinetop nor Lakeside had the required population of 2,000 to incorporate, but neither was willing to give up its name. The first and second attempts at incorporation failed. Finally, in 1984, a referendum to incorporate Pinetop-Lakeside passed. An interim council served until the general election, when residents elected a council. Attorney Jay Natoli was the first mayor, and Mary Ellen Bittorf was vice mayor.

The town of Pinetop-Lakeside already had a school district, two fire districts, two private water companies, and two post offices in place. Council members could concentrate on issues their constituents cared most about, including police protection, roads, planning and zoning, animal control, open space, and the acquisition of Woodland Lake Park, a parcel of national forest within the town borders. The three country clubs are outside town boundaries.

THEY CALLED HIM "MR. MACK." Walsh Mack was a one-man civil rights movement. He worked at the McNary mill until 1938, when Mabel Bowles, an independent lady who owned most of Pinetop, sold him three acres so he could start his own restaurant. "Mr. Mack" was six-foot-four with shoulders like Joe Lewis and hands like bear paws. He practiced his own brand of nonviolence. Nobody messed with him. He and his wife, Dolly, cooked the finest barbecued spareribs west of New Orleans. Their Dew Drop Inn was full every Saturday night. His friends included John Wayne, who liked to stop by when he was at his Springerville Ranch. (Courtesy Navajo County Library District.)

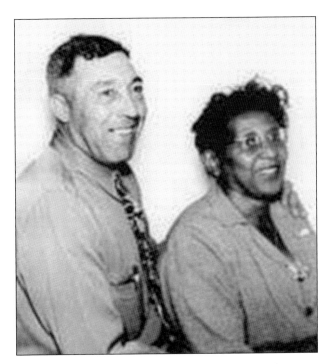

PENRODS ON THE PORCH. Charlene Penrod, her dad, Arch, and her sister Myrl did not sit around on the porch very often. When Arch was not making or selling liquor, he was managing a cattle ranch. Charlene was the proprietor of one of Pinetop's most popular bars, the Ponderosa Club. People came from all over to dance to country western music played by Bucky Goar and other local musicians. Myrl served in the military in World War II. (Courtesy Jack Reed.)

EVERYBODY'S BUDDY. Christened Marguerite Elizabeth, "Buddy" Wise was raised on a cattle ranch near Mesa Redonda by her parents, Charlie and Belle Clark. She graduated from Holbrook High School in 1938, the same year Charlie Clark bought the Pinetop restaurant that bears his name. As girls, Buddy and her sister Dolly helped in the restaurant. After graduating from Arizona State University and teaching for a year, Buddy joined the Army Air Corps in World War II, where she met her husband-to-be, Tom Wise. They owned Elaine's Dress Shop and Crosby's Men's Shop in Pinetop, serving customers from as far away as Phoenix and Tucson. They were married 54 years and had one son, Charlie. (Courtesy Gene Luptak.)

PINETOP LUMBERMAN. Harry and Maxine Turnbull and their children, Maxine Ann, Jim, Sandy, and Cheryl, moved to McNary in 1955, where Harry and his brother-in-law Gene Henning became business partners in a sawmill and logging enterprise. The Turnbulls lived in McNary for two years before building a home in Pinetop. The Turnbull-Henning business grew to include a Richfield service station, a hardware and lumber supply store, R&M Variety Store, and H&T Market in the center of Pinetop. When they dissolved the partnership, Turnbull kept Pinetop Lumber & Hardware, and Henning got the other businesses. (Courtesy Maxine Ann Turnbull.)

Businessman and Benefactor. Brothers Frank (left) and Tilden (right) Wilbur and their sister JoLynn grew up working in their father's grocery store in St. Johns. Following graduation from Arizona State University with a business degree, Tilden and his wife, Carol, moved to Pinetop to open a grocery store in 1955. Tilden built Ponderosa Plaza, the first mini-mall in Pinetop. He served his church, local schools, his community, and the surrounding area all his life, and was one of the founders of Northland Pioneer College. Tilden and Carol had five living children and were married 64 years. (Courtesy Julie Wilbur West.)

Rebuilt Shopping Center. In 1967, a record snowstorm dropped more than 100 inches of snow in Pinetop and caved in the roof of Wilbur's Market. Many people came to help, but others came to loot. Tilden's father and brother withdrew from the business, but Tilden stayed and rebuilt in the face of growing competition from larger chains. The shopping center featured a clothing store, a shoe store, Sprouse Reitz, and Wilbur's Market. One of Tilden's oldest and best friends was Walsh Mack. (Courtesy Julie Wilbur West.)

CARRYING ON TRADITION. Bill and Tricia Gibson, proprietors of Charlie Clark's Steak House in Pinetop, have expanded and modernized the business while preserving the friendly, informal Western atmosphere of the original version, when the restaurant consisted of two log cabins joined together. Raised in an Arizona ranch family, Bill is a collector of Western memorabilia and pictures. (Courtesy Bill and Tricia Gibson.)

FIRST BANK IN PINETOP. Banker Benton Snoddy hired a young Texas cowboy named Bill Cox as his assistant manager in McNary. Cox had come to Holbrook from Texas with a trainload of cattle at age 13. He cowboyed, worked at the bank, saved his money, went back to Texas, bought cattle, went broke in a drought, and returned to work for Snoddy. When Snoddy sold to the First National Bank, Cox went with it, becoming manager of the First National Bank when it opened a branch in Pinetop in 1963. The bank was later sold to Wells Fargo. (Courtesy Johnnie Fay McQuillan.)

25 YEARS IN BANKING.
Johnnie Fay McQuillan started working at the McNary bank when she was a 16-year-old high school student. She was transferred to the Pinetop branch of the First National Bank, where she worked as a loan officer until she retired. In this image, she is celebrating 25 years at the bank with her coworkers. She has been actively involved in numerous civic organizations and clubs, including the Women's Club, the hospital, St. Mary of the Angels Catholic Church, and the Blue Ridge Scholarship Fund. She also sews and quilts. (Courtesy Johnnie Fay McQuillan.)

PUBLISHING TRADITION. *Arizona's White Mountains*, an annual publication, has always been a family affair. The Meads have spent most of their lives camping, fishing, hiking, riding horseback, exploring, and promoting the White Mountains. Norman and Peggy Mead's children are carrying on the publishing tradition. From left to right are Norman Wesley Mead, Peggy Joyce Mead, Tray, Barry, Russell, and Brenda. (Courtesy Brenda Mead Crawford.)

PROMOTING THE MOUNTAIN. Since 1954, the Mead family has promoted Arizona's White Mountains through scenic photography and feature stories about history, travel, the outdoors, entertainment, and wildlife, and profiles of people and places. (Courtesy Mead Publishing.)

COVERING THE NEWS. The *White Mountain Independent* is a semiweekly broadsheet newspaper based in Show Low. It was started by Donovan and Ruth Kramer of Casa Grande in 1964 to cover the entire White Mountain region, including both Navajo and Apache Counties. An earlier newspaper was called the *White Mountain Eagle*. This photograph is of a special section covering the Rodeo-Chediski Fire of 2002. The entire staff was evacuated to Springerville, where they got the paper out on time. Following their heroic effort, they received an award for "Distinguished Community Service" from the Arizona Newspapers Association, which stated: "The staff worked with personal sacrifice and without regard for schedules to keep an entire community informed, involved and aware." (Courtesy *White Mountain Independent*.)

The Maverick. *The Maverick* hit the streets as a 16-page, black-and-white tabloid in March 2002. Publisher Kevin Birnbaum hired an inexperienced young woman named Amie Rodgers to sell ads. Before long, she became a business partner, and is now the editor and publisher of the glossy, full-color monthly magazine that is, true to its name, a maverick. Amie writes: "The *Maverick* is dedicated to the best of everything. At the risk of being labeled a 'feel good,' we focus on sharing the art, food, history, people, festivals and quality of life in the White Mountains." (Courtesy *The Maverick*.)

First Deputy. Ray Butler was southern Navajo County's first deputy sheriff. Navajo County was created in 1895 from Apache County, with the county seat, courts, and jail in Holbrook. For years, settlers in the White Mountains had to settle their own disputes or wait for a deputy to ride 60 miles from Holbrook to make an arrest. (Courtesy Gary Butler.)

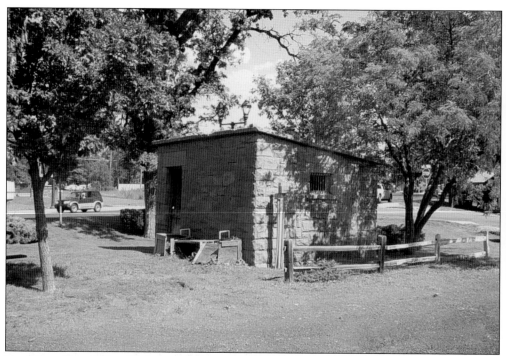

First Jail. Deputy Ray Butler put in a request for a jail in Pinetop in 1935. Stonecutters building Snowflake High School under the Works Progress Administration provided the labor. They built identical 12-foot-by-15-foot rock jails for Pinetop and Show Low. The first jail was located near the intersection of Highway 260 and Clare Lane. The First Interstate Bank planned to expand its building and parking lot there in 1987. Manager Bill Lundquist was instrumental in preserving and relocating the old jail to its present site, near the corner of Burke Lane and Highway 260. (Courtesy Gary Butler.)

Living a Legacy. Gary Butler, the grandson of Ray Butler, was elected Navajo County sheriff in 1989 and served for 20 years. In 1967, following his service as a Marine in Vietnam, he worked for Scottsdale Police, Apache County, Show Low Police, and was Show Low police chief. In 1988, he was elected sheriff of Navajo County. On his first day in office, he commanded a successful three-day manhunt for two men who had murdered a deputy. Butler took many steps to improve the sheriff's office, including the formation of the first criminal investigation team, the Major Crimes Apprehension Team, and the Sheriff's Auxiliary Volunteer Program. (Courtesy Gary Butler.)

KEEPING THE PEACE. Navajo County sheriff's deputy Charles Lane, a career lawman, served for many years as the only deputy working full-time in the Pinetop-Lakeside area. His easygoing nature belied his shrewdness in judging human nature that served him well in the diverse communities. His wife, Bonnie, was a local nurse. Charlie retired but remained a captain in the Reserve. He died while on duty and was buried in his uniform, as he had requested. (Courtesy Bonnie Lane.)

TAKING THE PONY EXPRESS OATH. The White Mountain Sheriff's Posse has approximately 50 highly trained members who are ready to leave their homes and businesses on a moment's notice to help with search-and-rescue operations when called by the Navajo County Sheriff's Office. One way they keep their horses in good condition is with an annual Pony Express Ride of 150–200 miles each spring. Here, the Lakeside postmaster swears in riders as mail carriers. (Courtesy Mark Sterling.)

HANDING OFF THE MAIL. Pony Express riders hand off mailbags in a full lope on their way to Globe or Tucson, taking back roads and trails used by the US Cavalry in days past. Each team of riders carries the mail in two-mile relays. Other riders follow with horse trailers, setting up relay stations along the way. From Lakeside, their route passes through the White Mountain and San Carlos Apache reservations and national forests. (Courtesy Mark Sterling.)

TIME OUT FOR STORIES. Longtime cowboy Verl Gillespie trades tall tales with deputy Charlie Lane at the Pony Express camp on the way to Globe. The annual ride is one way to promote camaraderie between "old-timers" and rookies. (Courtesy Mark Sterling.)

COMMUNITY PRESBYTERIAN CHURCH. Martha McNary Wilson Chilcote, a community leader who served for a time as Pinetop justice of the peace, led the drive to build the Community Presbyterian Church in Pinetop, which was dedicated in 1962. Across the street is St. Mary of the Angels Catholic Church, which had its origins in McNary. St. Anthony's was the first church building in McNary. Most of its members moved to Pinetop when the mill closed. With little but faith, an optimistic banker, and the support of summer residents, a log church was dedicated in 1974. Parishioners brought malapais rocks every Sunday to cover the church's exterior. (Courtesy Judi Bassett.)

THE SOUND OF MUSIC. Pinetop businessman Arthur Crozier was the dedicated organist of the Community Presbyterian Church until his death. Crozier and his sister Kim grew up in McNary, where their parents owned the only movie theater within 60 miles. His mother, Hattie, was a nurse at the McNary clinic. The Crozier family moved to Pinetop, where they owned and operated a highly rated restaurant. (Courtesy Lynda Marble.)

TEACHING THE LITTLE ONES. When the Rev. Arthur Alchesay Guenther retired as pastor of the Church of the Open Bible, in Whiteriver, in 1997, he and his wife, Gloria, moved to Pinetop. He devoted his "retirement" years to serving his new community in every possible way. One of them was teaching children and adults about White Mountain Apache culture. Here, he is talking to Christian Roman, a Blue Ridge Elementary School student. Reverend Guenther's godfather was Apache Chief Alchesay. (Courtesy Betty Jarrett.)

KEEPING THE FAITH. Historic Blooming Grove Baptist Church began in Louisiana and traveled to McNary in the hearts of the faithful who were shipped by boxcar to work in the mill in 1924. The first services were held in the "Negro Quarters" of the segregated town, with Pastor E.D. Hankins officiating. When the sawmill closed, many Blooming Grove members moved to Lakeside, including Pastor D.W. Lynn and his wife, Beatrice. The Lynns later moved to Show Low, where Reverend Lynn had a regular radio program. Beatrice taught music in McNary and Show Low. She died shortly after her 100th birthday. (Courtesy Vennie White.)

BROTHER RAYFORD. Willie Davis Rayford was born in Mississippi, where he lived until he joined the Army during World War II. After the war, he moved to McNary, where he was a takedown operator at the sawmill, taking down lumber after it was kiln-dried. When the mill closed, he and his wife, Willie Mae, moved to Lakeside. From 1985 to 1991, he worked for the Blue Ridge School District, and then for the Town of Pinetop-Lakeside for five years. He was a deacon at Blooming Grove Baptist Church. (Courtesy Patricia Blake Scott.)

MADDIE COOLEY, 2012 GRADUATE. Maddie Cooley, great-great-granddaughter of Col. Corydon Cooley, is pictured here during graduation. Pinetop-Lakeside schools have come a long way since 1906, when the first 13 students attended classes for five months out of the year in Niels Hansen's house. More than a century later, the Blue Ridge Unified School District has nearly 3,000 students in pre-kindergarten through 12th grade. Blue Ridge High School has a statewide reputation for excellence in sports and academics. In 2012 and 2013, Blue Ridge led the nation with 20 and then 29 All-American student-athletes. In 2013, a total of 44 percent of graduating seniors received scholarships to continue their educations. (Mike James photograph, courtesy *White Mountain Independent*.)

VICTORS. The Blue Ridge Yellow Jackets congratulate head football coach Paul Moro for his 45-0 win against St. Johns in October 2012, which was his team's 300th win. (Courtesy *White Mountain Independent*.)

LAST GAME. With 318 wins, only 14 games short of the state record, Paul Moro stepped down from coaching the Yellow Jackets to take another post in Florence for family health reasons. In his 30 years at Blue Ridge, he led his team to 13 state championships, more than any other Arizona coach. Firm but caring, Moro instilled a sense of pride and tradition in his teams. (Courtesy *White Mountain Independent*.)

FIRST CLUBHOUSE. This site was originally known as the Welch Springs Ranch. In the 1930s, a CCC camp was built there to "improve the recreation potential of the national forests." In the 1950s, a group of local golfers convinced the Forest Service it would be a perfect golf course. The first nine holes of the historic White Mountain Golf and Country Club were built on a shoestring, with donated labor, materials, and equipment. A Forest Service land exchange was completed in 1968, making it a private holding. (Courtesy Geoff Williams.)

COUNTRY CLUB. White Mountain Country Club is a private, member-owned club operating on a seasonal basis from May through October. The 18-hole course stretches out over 6,500 yards, every fairway lined with ponderosa pine trees. The course has bent grass greens, creeping bent fairways, and bluegrass/rye roughs. Best of all, there is no out-of-bounds on the golf course. If golfers can find their ball, they can hit it. It is the first of three Pinetop golf courses. (Courtesy Geoff Williams.)

BOB GATES AND CETA. Bob and Linda Gates take their dog Ceta everywhere. Ceta enjoys visiting nursing homes and rehabilitation centers as a therapy dog. When Bob and Linda retired and moved to Pinetop-Lakeside, they immediately became involved in the life of the town. Working closely with the chamber of commerce, the business community, and volunteers, they created the Run to the Pines Car Show, which attracts classic car owners from all over the Western United States. The car show is a major part of Pinetop-Lakeside's Fall Festival, which takes place on the last weekend of September. (Courtesy Lloyd Pentecost.)

CLASSIC CHASSIS. The Run to the Pines Car Show won the 2013 Arizona Governor's Tourism Award for Special Events. The first car show was held in a downtown parking lot in 1983. It was an immediate success and had to be moved to a larger venue. In recent years, it has taken place on the Pinetop Lakes Country Club driving range. With space for only 550 entrants, many of the pre-1973 vehicles have to be turned down. All proceeds over expenses go to local charities. The car show has raised more than $250,000 for charity over the years. (Courtesy *White Mountain Independent*.)

PURPOSEFUL LIFE. Mary Ellen Bittorf is a soft-spoken lady with an unshakeable determination to make Pinetop-Lakeside a community unified in purpose. That purpose is to protect the natural environment, provide municipal services, and preserve a sense of community. She and her husband, Chuck, a pharmacist, moved to Pinetop in 1970, where they owned the first drugstore. She led a new drive to incorporate Pinetop and Lakeside after two attempts had failed. When a referendum passed in 1984, Mary Ellen was elected to the first town council. She has served as vice president of the White Mountain Lions Club, president of the Audubon Society, chamber of commerce president, advocate for the acquisition of Woodland Lake Park, and founder of the Wildlife and Nature Center. Mary Ellen and Chuck have six children, all of whom worked in the family drugstore at one time. She hopes always to see trees and open spaces, and would like to bring in non-polluting corporate businesses. (Courtesy Bittorf family.)

POLICE CHIEF RON WHEELER. One of the town's first actions was to establish a police department in 1985. Prior to incorporation, Navajo County Sheriff's Office deputies enforced the law. An efficient communications system helps solve the challenge of working with different jurisdictions and agencies, including other police departments, the Navajo County Sheriff's Office, the Arizona Department of Public Safety, the FBI, the Bureau of Indian Affairs Criminal Investigation, USDA-Forest Service Law Enforcement, the Arizona Game and Fish Department, the White Mountain Apache Tribal Police, the Tribal Game and Fish Department, and the US Fish and Wildlife Service, in addition to regional fire and emergency services. (Courtesy Pinetop-Lakeside Police Department.)

HEADED OUT. The Pinetop Fire Department came into existence in 1958 when Martha McNary Wilson gathered a small group of volunteers to build a "fire station" on her property. The first firefighters were Martha, Archie Penrod, Dick Wilson, and Gerald Penrod. They had one truck and a party-line dispatch system. From that humble beginning, the volunteer department expanded to a fully equipped, first-class, full-time, career fire and emergency medical services department with two stations. Firefighters are cross-trained in urban and wildland firefighting. The department presently has 25 full-time firefighters, a chief and assistant chief, administrative personnel, seven reserves on standby, and a volunteer firefighter program. The department covers 212 square miles and a population of 5,000 that increases to 20,000 or more during the summer months. (Courtesy Daniel A. Greco, MD.)

THROUGH SMOKE AND FLAME. In January 1959, the business offices of the Navopache Electric Cooperative were destroyed by fire. Dewey Farr, the general manager of Navopache, began the process of forming a fire district. By May 1959, Lakeside had its own fire district. The volunteers were all people from the community. Navopache donated a 1949 Dodge Power Wagon, a small tank with a pump was installed, and firemen had their first pumper. The first station was built with donated materials and labor, and the Lakeside Fire Board was formed. A substation in Wagon Wheel was added in 1985. The board hired its first full-time fire chief, Paul Albinger, in 1988. Darny Wilhelm was assistant chief, and Joe Mettie became chief engineer. Improvements were made in training and equipment as the community grew. A new Dodge ambulance for first responders was put into use in 1994. Lakeside now provides Advanced Life Support, pre-hospital EMS, and medical transport services. Lakeside Fire Department presently has 27 full-time and 12 part-time employees. (Courtesy Lakeside Fire Department.)

Eight

TREES, TRAILS, AND CONSERVATION

As early as 1881, the territory formed a three-man Arizona Fish Commission whose primary job was enforcing regulations. Residents and nonresidents were required to buy hunting and fishing licenses in 1912, the year of statehood. In 1929, the Arizona Game and Fish Department was established to manage wildlife and fisheries. A hatchery was built in Pinetop to raise trout to stock lakes and streams. Later, the US Fish and Wildlife Service had a Pinetop office to manage Alchesay and Williams Creek National Fish Hatcheries, on the White Mountain Apache reservation.

Fishing brought more revenue to Pinetop-Lakeside and the White Mountains than any other activity in the last century. By 1940, most Arizonans had cars, and many liked to spend summer vacations camping in the mountains. They bought food, gasoline, and fishing gear in Pinetop-Lakeside. *Arizona Highways* magazine showcased the splendor of the White Mountains to the world.

World War II had an impact on every American town, and Pinetop-Lakeside was no exception. Young men and women served in the military, resulting in a labor shortage at home. Gas rationing slowed the tourist trade. Food rationing affected restaurants. Conversely, the demand for lumber kept the McNary mill operating at full capacity. Following World War II, the mass migration to the Southwest resulted in a construction boom that ensured sawmills and lumber companies stayed in business.

The whole world opened up to Native Americans who served in the military. They learned new trades and skills and went to college on the GI Bill. They had access to veterans' benefits and veterans' preference in applying for government jobs. White Mountain Apache leaders looked for opportunities to become economically competitive. With nearly 1.7 million acres of prime forests and grasslands, the tribe began managing its own resources for its own economic benefit.

The tribe created lakes, campgrounds, and a summer home development around Hawley Lake. The Wildlife and Outdoor Recreation Division managed its own wildlife and instituted a world-class trophy elk hunt. The tribal purebred Hereford ID herd was considered one of the best in the country, and cattle brought high prices at fall auctions.

Fort Apache Timber Company was built by the tribe in 1963 to manage its own timber resources and provide employment for tribal members. The tribe built gas stations and convenience stores in outlying communities, a hotel, restaurant, and shopping center in Whiteriver, and the Hon-

Dah Resort and Casino two miles south of Pinetop. The tribe's Sunrise Park Ski Resort attracts skiers from northern Mexico and the Southwest.

As the tribe prospered, so did Pinetop-Lakeside. Tribal members spend money off the reservation in retail stores, restaurants, and professional offices. They drive "Up the Hill" to shop, see the latest movie, get their hair styled, or have a pedicure. Many tribal members live, work, and educate their children in Pinetop-Lakeside, while retaining their family and clan connections.

Pinetop-Lakeside has suffered two major disasters in the past half century. The first was a 1967 blizzard that dropped 8–10 feet of snow in a brief time, cutting off communications, electricity, and roads for four days. Neighbors helped one another, shoveling snow off roofs and sharing food and firewood.

The second disaster was human-caused. The Rodeo-Chediski Fire of 2002 burned 468,638 acres along the Mogollon Rim. No deaths occurred, although 30,000 people were evacuated and more than 400 structures burned. Pinetop-Lakeside and Show Low were saved, largely because of the heroic efforts of Rick Lupe and two hotshot crews who conducted back-burns along Highway 60 to stop "the Monster" in its tracks.

The Rodeo-Chediski Fire proved that controlled burning of forests could prevent total loss. In 1950, BIA forester Harry Kallander of Pinetop advocated for controlled burning of portions of the forest in cool weather to reduce the fuel buildup that was causing large, destructive crown fires. In the 15 years Kallander was a BIA forester, crews control-burned nearly half of the reservation's timbered lands. The effectiveness of controlled burning was validated when the Rodeo-Chediski Fire burned in a mosaic pattern, leaving islands of timber intact. Forest Service and BIA crews regularly conduct prescribed burns, as well as mechanically thinning small trees. Special attention is paid to Wildland-Urban Interfaces, where towns meet forests.

In recent years, Pinetop-Lakeside's economy has leaned in the direction of outdoor recreation. With population growth in the 1980s came the threat of hikers and horsemen losing access to the forest from within the town. Volunteers worked with the town, property owners, and the Forest Service to create the White Mountain Trail System, which connects urban trails with national forest trails. Today, there are more than 200 miles of nonmotorized, multiuse, interconnecting trails for hikers, mountain bikers, horsemen, runners, and cross-country skiers. There are also trails for off-road vehicles.

The health of the forest is essential to the stability of ecosystems, the economy, and quality of life. The one element that unites all those who live on the mountain is the forest. The forest heals, supports, gives joy, and brings residents and visitors closer to nature.

SPRINGER MOUNTAIN LOOKOUT. Springer Mountain Fire Lookout overlooks the town of Pinetop-Lakeside. Lookouts, strung out across the forest, are the first line of defense against forest fires. Springer was one of the lookouts to spot the smoke of the Rodeo Fire on June 18, 2002. A second fire was spotted on Chediski Ridge later that day. The swiftly moving fires merged to become the Rodeo-Chediski Fire, the largest in Arizona history up to that time. (Courtesy USDA-Forest Service.)

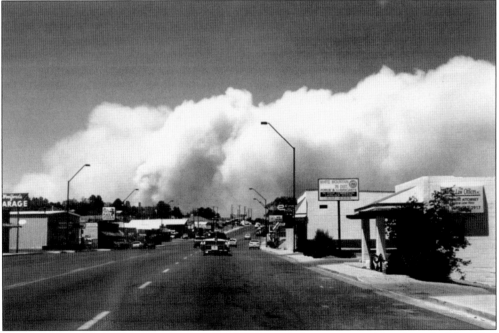

ESCAPING "THE MONSTER." Approximately 30,000 people from communities along the Mogollon Rim, from Forest Lakes to Pinetop, were evacuated during the Rodeo-Chediski Fire. This photograph was taken on the Deuce of Clubs in Show Low, showing cars headed east to shelters or friends' homes in St. Johns and Springerville. (Courtesy *White Mountain Independent*.)

PRESIDENTIAL SUPPORT. Pres. George W. Bush arrived at the Springerville Airport on June 25, 2002, in a small jet aircraft with his sleeves rolled up. He had flown in secretly with Arizona governor Jane Hull to get the latest information on the fire and offer his support to firefighters and evacuees at the Round Valley Dome emergency shelter. In this photograph, the president is greeting Pinetop-Lakeside mayor Ginny Handorf. (Courtesy *White Mountain Independent.*)

SLURRY BOMBER. Air attack continued day after day, with lead planes circling and air tankers dropping fire retardant on whatever spot was targeted. The "slurry bombers" refueled at the air tanker base in Winslow and kept going as long as light held out. Helicopters and Single Engine Air Tankers were also used. (Courtesy USDA-Forest Service.)

Bale Bombing. Immediately following the Rodeo-Chediski Fire, the Burned Area Emergency Rehabilitation Team moved in to begin forest restoration. Tree and grass seedlings were scattered over the entire burned area, nearly half a million acres, from fixed wing aircraft. Next, the area was "bombed" with straw bales thrown out of a helicopter. The bales broke apart in the air and scattered over the seedlings to protect them from erosion. Here, an Apache crew is loading hay bales. (Author's collection.)

Statue to a Hero. Eagle Scout Richard Genck raised money to fund this statue of White Mountain Apache firefighter Rick Lupe. The plaque at the base of the statue reads, "Richard 'Rick' Glenn Lupe, May 18, 1960 – June 19, 2003, A true American hero recognized as one of our Nation's greatest firefighters, died in the line of duty. 'Little do they know of our long labors on their behalf for the protection of their borders. And yet, I grudge it not.' – J.R.R. Tolkien." (Courtesy Judi Bassett.)

COMPOSTING DIGESTER. The Pinetop-Lakeside Sanitary District was formed when the Environmental Protection Agency compelled the town to replace its individual septic tank system with a municipal sewer system by denying new permits to developers. Ground percolation was so poor that leech lines were polluting Billy Creek and shallow groundwater. In 1976, the sanitary district board contracted with Lowry & Associates to build a state-of-the-art, environmentally sound wastewater disposal system. This photograph shows the original digester that chewed up biosolids and made compost. Operating engineer Phil Hayes said, "We have had people from all over the world come here to study the system." (Courtesy Pinetop-Lakeside Sanitary District.)

JAQUES MARSH. Through an innovative plan that involved the sanitary district, the town, the EPA, the Forest Service, and the Arizona Game and Fish Department, wastewater is now treated, aerated in ponds at the plant, and run through national forest lands to a series of man-made ponds and marshes to create a wetland habitat for waterfowl and other wildlife. (Courtesy Pinetop-Lakeside Sanitary District.)

WOODLAND LAKE PARK. The 580-acre parcel of forest, woodland, marsh and lake in the heart of Pinetop-Lakeside is used and cherished by those who love the outdoors. Developed by the Forest Service, the town, and volunteer groups, the park offers tennis courts, softball fields, volleyball courts, hiking, mountain biking, and equestrian trails, fishing, boating, picnic ramadas, charcoal grills, restrooms, playgrounds, and bird-watching opportunities. Big Springs is under a special use permit to the Blue Ridge Unified School District for an environmental study area. The land is owned by the national forest, but partners in management are the school district, the Arizona Game and Fish Department, the Town of Pinetop-Lakeside, and White Mountain Wildlife and Nature Center Inc. (Courtesy Jack Wood.)

HORSEMEN'S REST. In 1987, a group of 25 local horsemen met to discuss what to do about trail closures within the town as development increased. They decided to form the White Mountain Horsemen's Association (WMHA) and unite in an effort to create a series of multiuse, interconnecting loop trails from Vernon in the east to Clay Springs in the west. Businessman Jerry Handorf did most of the mapping, designing, planning, and organizing, with the help of Bev Garcia and others. The Forest Service approved the proposed trail system in 1989. Jerry's initial work with the WMHA led to the development of the 200-mile White Mountain Trail System. (Courtesy Bev Garcia.)

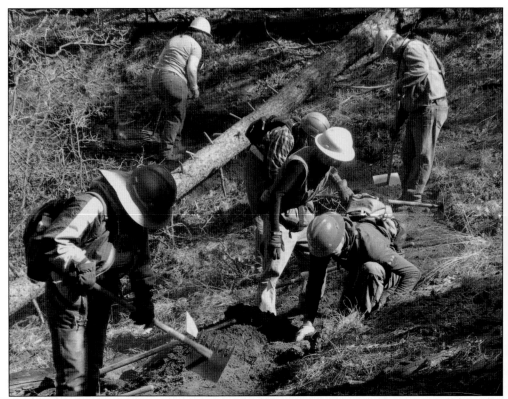

TRAIL BLAZERS. TRACKS is one of the hardest-working groups on the mountain. The volunteer organization is dedicated to using, promoting, preserving, and protecting multiuse, nonmotorized trails throughout the White Mountains. TRACKS also participates in community events, such as National Trails Day, Tour of the White Mountains, and the fall "leafing" hike and pot luck. Members meet for breakfast and do weekly trail maintenance throughout the White Mountains. (Courtesy Judi Bassett.)

NATURE CENTER. The Nature Center, on Woodland Road, is an outgrowth of Mary Ellen Bittorf's love of nature and animals. Children and adults come to hear talks on wildlife by experts. This owl is probably a visitor from the Adobe Mountain Wildlife Center in Phoenix, which cares for and rehabilitates injured wildlife. (Courtesy Judi Bassett.)

GINNY HANDORF. Handorf was mayor of Pinetop-Lakeside during the Rodeo-Chediski Fire. She and her husband, Jerry, have been active in many community affairs along with operating a small business. Among her many accomplishments, Handorf sings with the White Mountain Chorale, is choir director for St. Mary of the Angels Catholic Church, has organized drama groups and productions, and served on the board of directors of Northland Pioneer College. (Courtesy Handorf Family.)

BIRD WATCHING. The White Mountains are home to many species of birds, from migrating waterfowl to bald eagles, ospreys, and all colors and sizes of songbirds. The White Mountain Audubon Society holds monthly meetings, participates in bird counts, and is dedicated to providing environmental leadership and awareness through fellowship, education, community involvement, and conservation programs. (Courtesy USDA-Forest Service.)

DISCOVER THOUSANDS OF LOCAL HISTORY BOOKS
FEATURING MILLIONS OF VINTAGE IMAGES

Arcadia Publishing, the leading local history publisher in the United States, is committed to making history accessible and meaningful through publishing books that celebrate and preserve the heritage of America's people and places.

Find more books like this at
www.arcadiapublishing.com

Search for your hometown history, your old stomping grounds, and even your favorite sports team.